WALTERCIO CALDAS

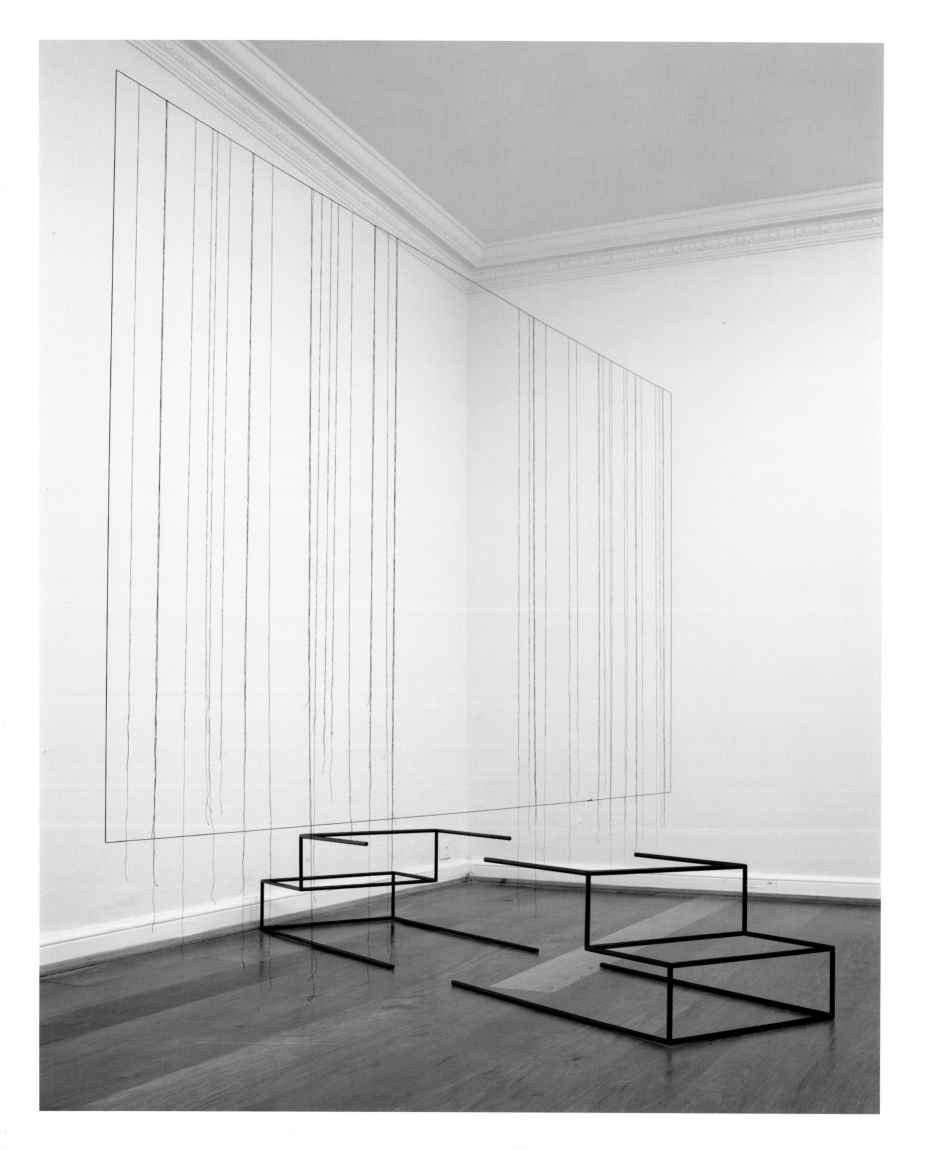

WALTERCIO CALDAS

BLANTON MUSEUM OF ART

UNIVERSITY OF TEXAS PRESS | Austin

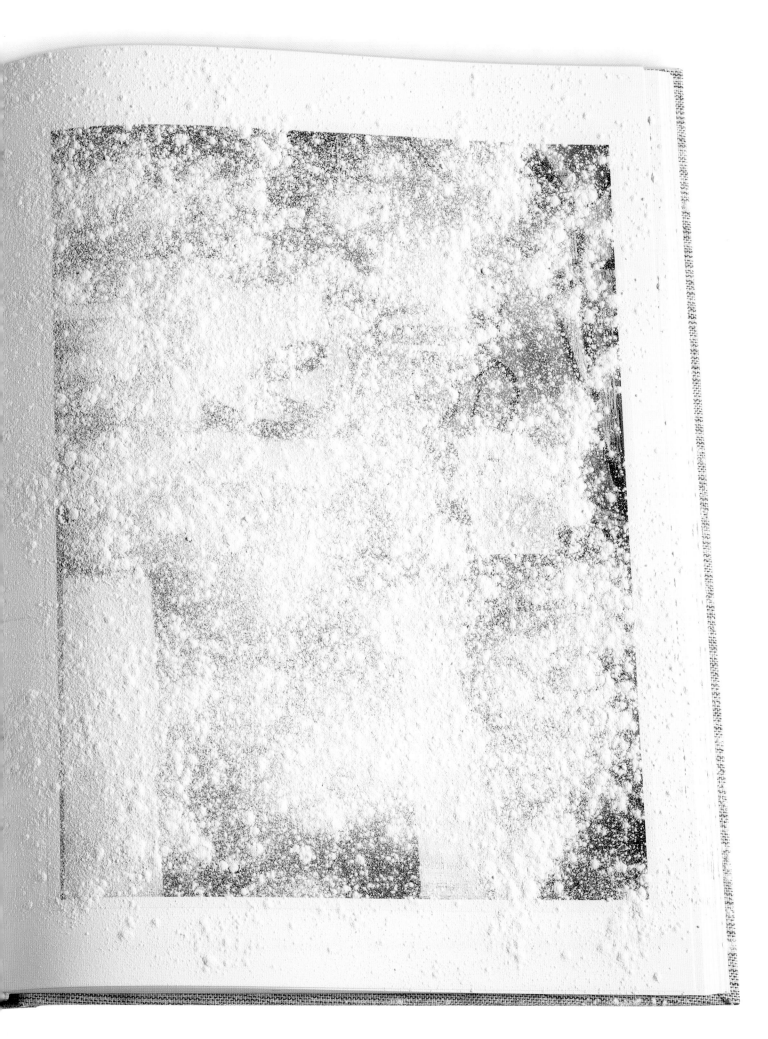

This book was published in conjunction with the exhibition *The Nearest Air: A Survey of Works by Waltercio Caldas* (October 27, 2013–January 12, 2014), co-organized by the Blanton Museum of Art and the Fundação Iberê Camargo.

This publication was underwritten in part by Michael Chesser. Production support was provided by Jeanne and Mickey Klein in honor of Judy Tate. Generous funding for the exhibition at the Blanton was provided by the Susan Vaughan Foundation, with additional support from Patricia Phelps de Cisneros and the Bruce T. Halle Family Foundation.

Requests for permission to reproduce material from this work should be sent to:
 Permissions
 University of Texas Press
 P.O. Box 7819
 Austin, TX 78713-7819
 http://utpress.utexas.edu/index.php/rp-form

♾ The paper used in this book meets the minimum requirements of ANSI/NISO Z39.48-1992 (R1997) (Permanence of Paper).

LIBRARY OF CONGRESS
CATALOGING-IN-PUBLICATION DATA

Waltercio Caldas. — First edition.
 pages cm
 "Published in cooperation with the Blanton Museum of Art."
 Includes bibliographical references.
 ISBN 978-0-292-75311-2 (cl. : alk. paper)
1. Caldas Júnior, Waltércio, 1946—Exhibitions. I. Caldas Júnior, Waltércio, 1946– Works. Selections. II. Pérez-Barreiro, Gabriel. Octopus and a completely full aquarium. III. Shiff, Richard. Question. IV. Storr, Robert. Mirage maker. V. Rodríguez, Mari Tere. Chronology, 1946/2012. VI. Blanton Museum of Art, host institution.
 N6659.C34A4 2013
 709.2—dc23 2012047721

PHOTO CREDITS

Jaime Acioli: frontispiece, iv–v, viii, 12–13, 18, 21, 26, 50, 51, 56–57, 66, 67, 69, 70–71, 74, 76, 78, 98–99, 100, 101, 113, 116, 117, 119, 126–127, 138
Sérgio Araújo: 8–9, 45, 84
Archive of Waltercio Caldas and Patrícia Vasconcellos: 102, 103, 114–115
Cesar Caldas: 47
Roberto Cecato: 12, 82–83
André Chassot: 10
Colección Patricia Phelps de Cisneros: 45, 60
Paulo Costa: 19, 22, 63
Theresa Diehl: 75
Rômulo Fialdini: 23, 43, 44, 49, 52–53, 58, 61, 64
Rick Hall, courtesy Blanton Museum of Art: 42, 90, 91, 92–93, 94
Ken Howie, courtesy Phoenix Art Museum: 79
Wit McKay, courtesy Galerie Lelong, New York: 30
Vicente de Mello: 15, 16–17, 20, 24–25, 28, 29, 33, 72, 73, 105, 111, 128, 134
Wilson Montenegro: 5, 6, 14, 65, 118, 123
Victor Muñoz: 31
Hans Pattist, courtesy Stedelijk Museum Schiedam, the Netherlands: 124–125
Photographic Services Art Basel: 106–107, 108, 109
Fábio Del Re: 112
Georg Rehsteiner, courtesy Centre d'Art Contemporain Genève: 34–35
Miguel Rio Branco: xiv, 11, 59, 77, 81
Marina B. Valença: 96, 120
Bruce M. White, courtesy MoMA, New York: 48

[Previous pages]

A MÁQUINA LOCAL
(*THE LOCAL MACHINE*), 1969–2013

Acrylic on iron, rubber band, yarn
Dimensions variable

Private collection, Rio de Janeiro

MATISSE, TALCO (*MATISSE, TALCUM*), 1978

Talcum powder over illustrated book on Henri Matisse
13 × 20 1/16 × 1 9/16 in. (33 × 51 × 4 cm)

Private collection, Rio de Janeiro

CONTENTS

RELÓGIO (THE WATCH), 1975

Black ink and watercolor on paper
12⅝ × 12⅝ in. (32 × 32 cm)

Private collection, Rio de Janeiro

FOREWORD

Simone Wicha, Director
BLANTON MUSEUM OF ART

IN 2011, I VISITED WALTERCIO CALDAS in his beautiful house in Rio de Janeiro, where he spoke freely about his process and the evolution of his work, which encompasses drawings, sculptures, installations, and artist's books. His personality reflected the elegance and refinement that characterize his art. Often simple in composition, it invites a host of complex questions about perception and space. Caldas challenges not only the way we look at his objects in the moment, but also our perspectives on art more generally. For decades he has been a central figure in Brazilian art. While his influence extends across much of the art world, he has remained largely underrecognized in the United States. *The Nearest Air: A Survey of Works by Waltercio Caldas* brings his work to a broader audience. This endeavor highlights one of the Blanton Museum of Art's core commitments: to identify exceptional artists from Latin America and to present their work in a global context to students and the public.

Years ago, when still curator of Latin American art at the Blanton, my former colleague Gabriel Pérez-Barreiro often spoke about Caldas as a key artist whose work he felt warranted wider consideration. Gabriel was responsible for the Blanton acquiring two important works by Caldas: *Velázquez* and *Escultura em granito*, the latter purchased as a gift of Margaret McDermott in memory of Barbara Duncan. When the opportunity for this project arose some years later, we jumped at the chance. We invited Gabriel as guest curator and partnered with the Fundação Iberê Camargo, a premier art organization in Porto Alegre, Brazil, that has a distinguished history of organizing contemporary art exhibitions. We are deeply indebted also to Caldas, who generously gave his time and energy at every stage of the project. The results are the first survey of Caldas's long and impressive career and this comprehensive publication documenting his trajectory, influences, and impact.

We could not have undertaken this project were it not for the partnership of the Fundação Iberê Camargo. Such alliances exemplify the Blanton's emphasis on pursuing strong, mutually beneficial institutional relationships that encourage cross-cultural dialogue. Through such relationships, the Blanton participates in the dissemination of Latin American art and culture by providing U.S. audiences with the opportunity to encounter artists whose importance extends beyond geography. We thank Fábio Coutinho, director of the Fundação Iberê Camargo, for his vision and commitment, and his staff, including Pedro Mendes, Adriana Boff, and Carina Dias. We are grateful also to the Pinacoteca do Estado de São Paulo for its presentation of *The Nearest Air*, and we extend special thanks to Marcelo Araújo, secretary of culture of the State of São Paulo, and Ivo Mesquita, artistic director of the Pinacoteca.

Bringing Caldas's work to the Blanton, which is part of the University of Texas at Austin, stimulates intellectual discourse among faculty and students. One of the great advantages of a university art museum is the opportunity to work on a campus with great intellects. Professors, along with the Blanton's curators and

educators, present works of art to students and other visitors and help contextualize the works within disciplines as wide-ranging as music, math, and philosophy. To foster new knowledge and perspectives on Caldas, we invited leading scholars to contribute essays to our publication, including Richard Shiff, art historian, critic, and Effie Marie Cain Regents Chair in Art at the University of Texas; and Robert Storr, artist, critic, and dean of the Yale University School of Art.

The Blanton's collection of 1,800 works of modern and contemporary Latin American art is recognized as one of the oldest, largest, and most comprehensive collections of its kind in the United States. Scholars and students working with the collection can draw from a number of other rich resources at UT that provide an unparalleled cultural trove from which to develop projects like *The Nearest Air*. These include the world-renowned Teresa Lozano Long Institute of Latin American Studies, the Nettie Lee Benson Latin American Collection, and the College of Fine Arts, which has the longest-running program of Latin American art history in the United States.

Such a robust array of intellectual resources in an environment dedicated to research and learning allows the Blanton to be adventurous and flexible in its ambitions. In many ways, the museum acts as a classroom for discovery and the exchange of ideas, allowing us to engage visitors in innovative ways and introduce new audiences to art and ideas that they may not otherwise encounter. We hope this exhibition will help catalyze conversations about how we perceive our environment and other ideas explored in Caldas's compelling work.

In addition to those already mentioned, we would like to thank a number of others for their work on this project. We are especially thankful to Caldas's wife, Patrícia Vasconcellos, for her immense help. The Blanton's former associate curator of Latin American art, Ursula Davila-Villa, oversaw key aspects of the exhibition and publication and advanced the project with characteristic diligence and skill through its initial stages before her departure from the museum. Annette DiMeo Carlozzi coordinated the later stages of the exhibition's presentation at the Blanton. Graduate students—the next generation of professionals in the field—made important contributions: Mari Tere Rodríguez produced the chronology for this publication and helped manage exhibition logistics; Amethyst Rey Beaver produced the bibliography for this volume. Our thanks go to Dalia Azim for proficiently guiding the book through publication. This project benefited from the work of the entire Blanton staff, and, in particular, we thank Ray Williams, director of education and academic affairs, and James Swan, head of installations.

This project would not have been possible without the generosity of the Bruce T. Halle Family Foundation and the Susan Vaughan Foundation, both of which supported the exhibition at the Blanton, and Michael Chesser, who underwrote the production of this publication. The Blanton is deeply grateful to Judy and Charles Tate and to Jeanne and Michael Klein for their steadfast support and their belief in fostering a love for art and artists among our students. We owe thanks to our generous Blanton Museum Council whose enthusiastic commitment and belief in our mission enhances all our efforts. We are further indebted to numerous other dedicated people who were instrumental in the success of such an ambitious and exceptional project.

PREFACE AND ACKNOWLEDGMENTS

FUNDAÇÃO IBERÊ CAMARGO

THE IBERÊ CAMARGO FOUNDATION was founded in 1995 from a desire of Iberê Camargo and his wife, Maria Coussirat Camargo, to preserve his work, with the support and leadership of Jorge Gerdau Johannpeter and representatives of several groups of society. Since its establishment, the Foundation has aimed to conserve and promote the work of this important Brazilian artist and to encourage systematic reflection upon and discussion of modern and contemporary artistic production. Every year the foundation presents exhibitions, and its interdisciplinary programs include workshops, seminars, meetings with artists, and a variety of studies on subjects related to modern and contemporary art—as well as on the work of the artist—stimulating its audiences' interaction with art, culture, and education.

In this spirit, we are glad to see come to fruition the collaboration between the Iberê Camargo Foundation and the Blanton Museum of Art that has resulted in *The Nearest Air: A Survey of Works by Waltercio Caldas / Waltercio Caldas: O ar mais próximo e outras matérias*. The exhibition elicits central questions about the work of Waltercio Caldas and addresses many issues that permeated his artistic production throughout the years.

This magnificent project—with almost eighty works, including drawings and sculptures, objects and installations—offers a glimpse of Caldas's entire artistic production so far, one of the most prolific in Brazilian art. The works of Caldas create a constant challenge to our cognitive beliefs and our perception of materials and space. The artist's choice of simple and familiar elements allows viewers a preliminary approach to a work's composition, but that primary recognition soon gives way to new opportunities of interpretation of the work and, as a consequence, of art itself.

The exhibition is accompanied by two catalogues: this one, with three essays shedding light on Caldas's trajectory and influences; and one produced separately by the Iberê Camargo Foundation, containing, besides the imagery from the exhibition and the curatorial essays, six seminal essays by a different group of art critics on Caldas's work and his impact on Brazilian and international art.

Organized by the Iberê Camargo Foundation and the Blanton Museum of Art, the exhibition *The Nearest Air: A Survey of Works by Waltercio Caldas / Waltercio Caldas: O ar mais próximo e outras matérias* was presented from September to November 2012 in Porto Alegre, from February to April 2013 at the Pinacoteca do Estado de São Paulo, and from October 2013 to January 2014 at the Blanton.

Another interdisciplinary program, however, marked the first collaboration between the Iberê Camargo Foundation and the Blanton: an artistic residency at the Blanton in 2007 by the Brazilian artist Matheus Rocha Pitta, winner of the Iberê Camargo Grant. Instituted in 2001, the grant program allows young Brazilian artists to study abroad at partner institutions, annually offering residency spots for those pursuing art research, study, and production.

To be part of this continued partnership with the Blanton demonstrates the commitment of the Iberê Camargo Foundation to excellence in cultural, educational, and research programs on modern and contemporary art. Part of this excellence is grounded in the belief that generating and amplifying connections between institutions should happen not only locally and regionally, but also internationally, with the goals of fostering the exchange of information, knowledge, and experiences, and of aiming for a stronger dialogue between the Americas and their many audiences in the visual arts.

The Iberê Camargo Foundation is grateful to Waltercio Caldas and to the cocurators of the exhibition, Gabriel Pérez-Barreiro, director of Colección Patricia Phelps de Cisneros (New York and Caracas), and Ursula Davila-Villa, former associate curator of Latin American art at the Blanton, for all the time and attention that they dedicated to this project; to Simone Wicha, director of the Blanton, for her work in fostering this collaboration and in bringing the artistic production of this important artist to new audiences—and to the whole Blanton team; to the entire Fundação Iberê Camargo team, which worked hard to bring the concept to life; to the Pinacoteca do Estado de São Paulo, for its support in executing the exhibition in Brazil; and to the sponsors and all involved in making this project a success.

WALTERCIO CALDAS

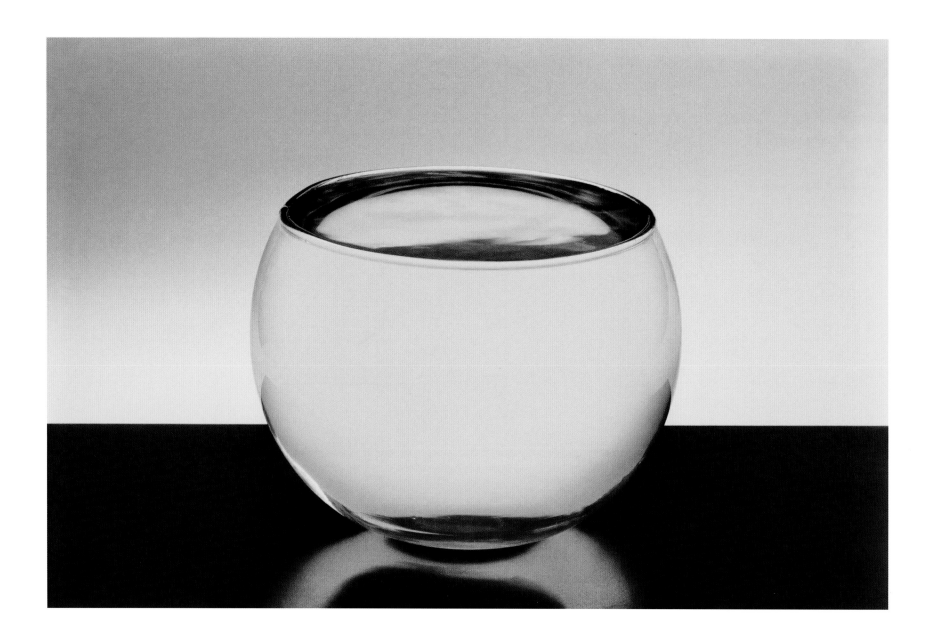

AQUÁRIO COMPLETAMENTE CHEIO
(*COMPLETELY FULL AQUARIUM*), 1981

Glass and water
13¾ × 11¹³⁄₁₆ × 11¹³⁄₁₆ in. (35 × 30 × 30 cm)

Private collection, Rio de Janeiro

THE OCTOPUS AND A COMPLETELY FULL AQUARIUM

WALTERCIO CALDAS

———

Gabriel Pérez-Barreiro

Art is concerned with something that cannot be explained by words or literal description . . . Art is revelation instead of information . . . Art is concerned with the HOW not the WHAT, not with the literal content but with the performance of the factual content. The performance—how it is done—that is the content of art.

—JOSEF ALBERS

APPARENTLY, A LIVE OCTOPUS IS 90 percent water. Somehow—don't ask me how—this random fact came up in a conversation with Waltercio Caldas, who, after a split second, came back with "or in other words, all water is 10 percent octopus."[1] This seemingly throwaway comment reveals not only the artist's unique logic and intellectual process, but also his legendary humor. Caldas's sculptural works constantly navigate the porous borders between positive and negative, container and contained; as with the relationship between the octopus and water, Caldas's work simultaneously explores what is without and within. All sculpture fundamentally deals with such shifts of perspective, but Caldas places them at the center of his artistic inquiry in order to create a type of visual philosophy that is as stimulating to experience as it is hard to describe.

The challenges inherent in describing Caldas's work are legend. It is hard to think of a contemporary artist whose work so doggedly and skillfully evades the verbal, the narrative, the descriptive, and thus defies the rules of an art system that demands easily digested and marketable products. Although Caldas's work is consistently unique and identifiable, it is impossible to predict what form, material, scale, or appearance his next

exhibition will take. It is also difficult to trace his artistic development in chronological terms; certain works from the 1970s, for example, live comfortably alongside more contemporary pieces, complicating the notion of linear progression. His body of work draws from a complex web of influences and dialogues, and returns with something just as myriad and layered.

Caldas's work has generally been overlooked or misread in the recent surge of interest outside Brazil in Brazilian art. While many artists of his generation have achieved long-overdue international recognition, Caldas remains something of an insider: hugely important and respected locally but less well known beyond Brazil. It is interesting to consider why this might be the case. On the one hand, Caldas's work does not conform to—in fact, it aggressively resists—many of the stereotypes that continue to haunt Latin American art. While the tendency to exoticize Latin America has significantly diminished, a quick study of Brazilian "stars" in the art market and the circuit of biennials reveals work that, while certainly more refined and self-consciously cosmopolitan than the magical realism of decades ago, still contains a mandatory allusion to stereotypes of tropical Brazil. Caldas's work exists on a fault line in the eyes of its international viewers: straddling the growing understanding of the tremendous sophistication of Brazilian art and culture, and the need for it still to be "different" in traditional ways. Caldas's work is profoundly Brazilian, and indeed could not have been made anywhere but in Rio de Janeiro during the second half of the twentieth century, but at the same time rigorously avoids the narrow definitions often imposed on art from Latin America.

In addition to the complications arising from the cultural geopolitics relating to the reception of Caldas's work, it is worth looking at the work itself to see how it implicitly evades categorization. First impressions can be misleading, and in this case the extreme elegance of the sculptures, their refined and expensive materials, and impeccable assembly all give off signals that invite a certain misreading. To the unfamiliar eye, Caldas's sculptures can look cold, calculating, or even corporate. Yet those who spend time with the work speak with conviction about precisely the opposite qualities: warmth, humor, seduction. That great disparity raises the question whether the first impression is a foil, part of a strategy intended to pull in the viewer and intentionally mislead him or her. The question of style and its relationship to meaning is an old one in art history, but its contemporary implications are particularly complex. In the postmodern era, as we become more and more accustomed to processing images at speed, and as contemporary art has largely embraced the literal or discursive over the visual as the battleground for ideas, our collective distrust of visuality has reached a fever pitch. There is a prevalence of "about" art, as I like to call it, within contemporary culture: art that can be reduced to a mission statement—"my work is about . . ."—which puts the (often banal) agenda ahead of the work itself. Caldas deploys beauty—both in his materials and compositions—not for its own sake but to create a space in which a certain kind of experience can occur, and as a form of resistance to the dominant cultural logic. The experience of Caldas's work ultimately has to do with an acute and precise questioning of the relationship between visuality and meaning: the way our eyes connect to our minds.

Every visual stimulus ultimately leads to an opinion: we see, and then we process. In pedagogy, one of the measures of critical thinking is the lapse between exposure to a stimulus and the formation of an opinion; the longer the time between the two, the richer and more nuanced the response. Time is an essential factor in perception, and duration is a determinant of quality of experience. The challenge for the critical visual artist is to slow down that process in order to make it richer and productive rather than reactive and predictable. To do so, the artist must avoid recognition, since recognition represents the rapid associating of a new stimulus with an existing one, which shortcuts the experience of looking. In our overly stimulating environment, making such associations becomes a matter of survival, the only way to process all that we encounter daily. Caldas's work attempts to subvert this tendency: to slow time down enough to allow for doubt, unfamiliarity, and questioning to enter the equation; ultimately, the goal is to inspire the creation of new meanings. The idea of art as something generative and complex rather than transactional and efficient is fundamental to understanding Caldas's position; it also helps explain the difficulty of summarizing his work conventionally.

The impulse to create new meanings by slowing down perception and judgment is central to understanding why Caldas's work looks the way it does. A risk for all artists is that a signature style, an easily recognized formal shorthand, can threaten their work with redundancy, creating a vicious circle in which a viewer's expectations are confirmed again and again. That tendency can foster popularity and commercial success, but not necessarily good art (history is littered with negative examples: Salvador Dali, Marc Chagall, Jim Dine). Caldas's work provides an alternative model in which each encounter has the potential to foster a new experience. One of Caldas's favorite expressions is that he doesn't create objects but the spaces between objects; this is true not only of the works' formal qualities (they do indeed contain much "empty" space) but also, and more importantly, as a pointer to the way in which content and meaning are generated. The responsibility does not lie solely with the work or the viewer, but in the interaction between them. Of course, this could be said of all art, but I argue that in Caldas's work there is a heightened sensitivity to this interaction. In an exhibition of works by Caldas, one *feels* the invisible content, a sensation that is simultaneously corporeal, ethereal, and intellectual.

Upon first contact, many people classify Caldas's work as geometric abstraction. Yet it is a mistake to categorize his work as purely formalist. Caldas's elements are classically formal (geometry, balance, purity), yet his work resists being read into the tradition of concrete art, a movement that began in Europe in the 1930s as a celebration of pure form and later spread across South America, where it took particular hold in São Paulo and Rio de Janeiro. Caldas's relationship to the movement is both ideological and contingent. By ideological, I mean that he consciously complicates the discoveries of the 1950s and 1960s, the era of heroic modernism in Brazil, and updates them to include contemporary questions of perception, of how we can continue to be moved by forms that are no longer "new." By contingent, I mean that Caldas understands the impossibility of reviving formal solutions in our current state of contemporaneity. The stakes today are different in almost every way from those of

half a century ago, and Caldas's solutions, while they may quote from the past, do not seek to revive or comment upon it.

Caldas employs several formal devices to explore the complicated relationship he has with his historical predecessors. He incorporates words (often the names of artists or musicians mounted on or etched into acrylic) into his work to discourage formal, disinterested engagement; he occasionally uses unexpected colors to achieve the same effect. These references to elements outside the artwork prevent it from being read in purely formal terms. The inclusion of names like "Thelonius Monk," "Braque," or "Giotto" in Caldas's work offers clues about the artist's sources of inspiration, and yet such references remain oblique. Caldas's frequent quotations from art history are not intended as critiques but rather as playful nods or provocations meant to initiate encounters with the work of his peers.

Outside Brazil, Caldas has frequently been placed in the camp of minimalism, a movement whose spirit was captured in a famous quip by Frank Stella: "What you see is what you see." Stella's words imply a fatigue with certain kinds of art and propose a more matter-of-fact alternative. This almost Calvinist approach to art making was in many ways a North American postwar phenomenon, though its roots trace back to Paris, where in 1930 Theo van Doesburg and a group of cohorts signed the concrete art manifesto. Among its central doctrines: "A pictorial element has no other significance than itself and consequently the painting possesses no other significance than itself."[2] Despite its birth in Europe, concrete art's most enduring legacy was manifested in the Americas—North and South—where it influenced the Asociación Arte Concreto Invención in Argentina in the mid-1940s, and Brazilian concretism in the 1950s, before traveling north to affect U.S. minimalism in the 1960s. The uniquely Brazilian reading of van Doesburg's ideas was filtered through a strong interest in Gestalt psychology and visual psychology, which can be seen in the works of Geraldo de Barros, Waldemar Cordeiro, and Judith Laund, among others.[3] The twist away from reductive materialism hugely influenced the evolution of Brazilian art over the next few decades; Caldas's work is inconceivable without that historical turn. The combination of Euclidean geometry with other interests—the organic, the social, the body—allowed Brazilian

artists to avoid the zero-sum game of reductive geometry for its own sake and to create a field of possibility that continues to be rich and productive.

The other art historical term that often arises in casual discussion of Caldas's work is conceptual art. While the work is, of course, conceptual—since it is clearly *not* figuration, expressionism, performance, or any number of other terms—it nonetheless stands quite apart from the tradition of conceptual art as we have come to understand it. If we follow Luis Camnitzer's somewhat controversial but useful division of conceptual art into a tautological tradition (exemplified by Joseph Kosuth) and a political one (most Latin American artists, such as Cildo Meireles or Alfredo Jaar), it becomes doubly clear that Caldas belongs to neither tendency.[4] His work is not political in an ideological or activist way, nor is it a detached statement about the nature of visuality in relation to the verbal. While Caldas's origins coincide with the birth of conceptualism in Brazil, the development of his work took a quite different direction, offering a more poetic and suggestive message than one that tried programmatically to express a political position.

It can be instructive to think of the history of abstract art as attempts to grapple with empty space. When a three-dimensional form encloses empty space, we are left to wonder whether that encompassed space itself holds meaning. Many agree on what "form" means, and the definition of that term is usually tinged with reductionism (it is what it is). When it comes to empty space, definitions vary. The Russian constructivist brothers Naum Gabo and Antoine Pevsner explored the concept of empty space in their dynamic fields; the American Sol LeWitt did the same through his equivalent modules; and the Brazilian Hélio Oiticica approached it through an implicit human body in the folds of his *parangoles*. The definition of nothingness is perhaps the most instructive place to look when trying to understand the ideological differences between artists who share the language of minimalism but not the same intentions. Caldas profoundly detaches from minimalism in his rejection of the matter-of-factness of space. The question for him boils down to this: Is empty space nothing or something? And if it is something, what kind of something is it?

Caldas's *Completely Full Aquarium* eloquently summarizes many of the artist's interests, particularly as they relate to the question of empty space. The technical description of the work couldn't be simpler: an aquarium filled with water. But to fully understand the work, we must take into account both the space that surrounds it and our shifting perceptions of the object. The aquarium acts simultaneously as a mirror and a lens through which to view everything around it. The work complicates notions of what we are seeing, even though we interact with its materials—glass and water—every day. The work makes us aware of something different, and that realization encourages us to stop and question our impressions. There is no trickery apparent here; even the title of the work announces what the object is, with mocking obviousness: a completely filled aquarium. But its plenitude makes central the question of what is in the aquarium: we read it as air, even when we expect it to be water, and then we confirm that it is water after all. While all this may sound banal, the work manages to enchant the viewer with its everyday, simple beauty. The resulting delight has little to do with art theory and much to do with poetics. While conceived as a sculptural object, the work becomes something else as well; physically and metaphorically, it acts as lens through which to see the world. While *Completely Full Aquarium* is, at its most basic level, an exercise in redundancy (it really is what it says it is), in fact it could not stray further from the crushing logic of tautology.

Caldas applies this same oblique, probing vision to his book *Velázquez*, which takes questions of presence and absence, reality and illusion, and applies them to the history of art writ large. By manipulating the images in an art history textbook—blurring the details and removing the figures—Caldas creates an extended essay on representation and meaning, calling into question our relationship with reproduced images and notions of truth. Countless modern and postmodern artists and philosophers have revisited the work of Diego Velázquez, but Caldas does so in a typically atypical fashion, focusing on how most of us encounter the work of Velázquez: through textbooks rather than through physical encounters with the paintings. The blurry pages of Caldas's book transport the object into another realm, as if it were an object represented in the distance of a painting, where we would expect its images to be indistinct.

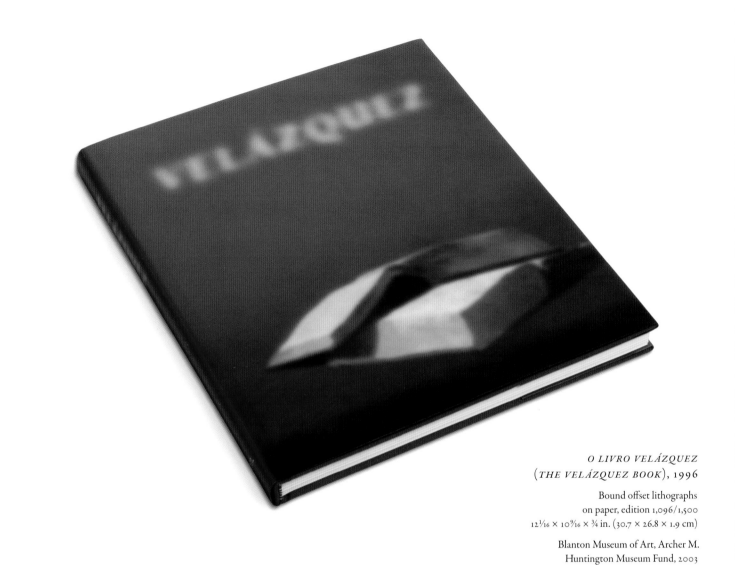

O LIVRO VELÁZQUEZ
(*THE VELÁZQUEZ BOOK*), 1996

Bound offset lithographs
on paper, edition 1,096/1,500
12 1/16 × 10 9/16 × 3/4 in. (30.7 × 26.8 × 1.9 cm)

Blanton Museum of Art, Archer M.
Huntington Museum Fund, 2003

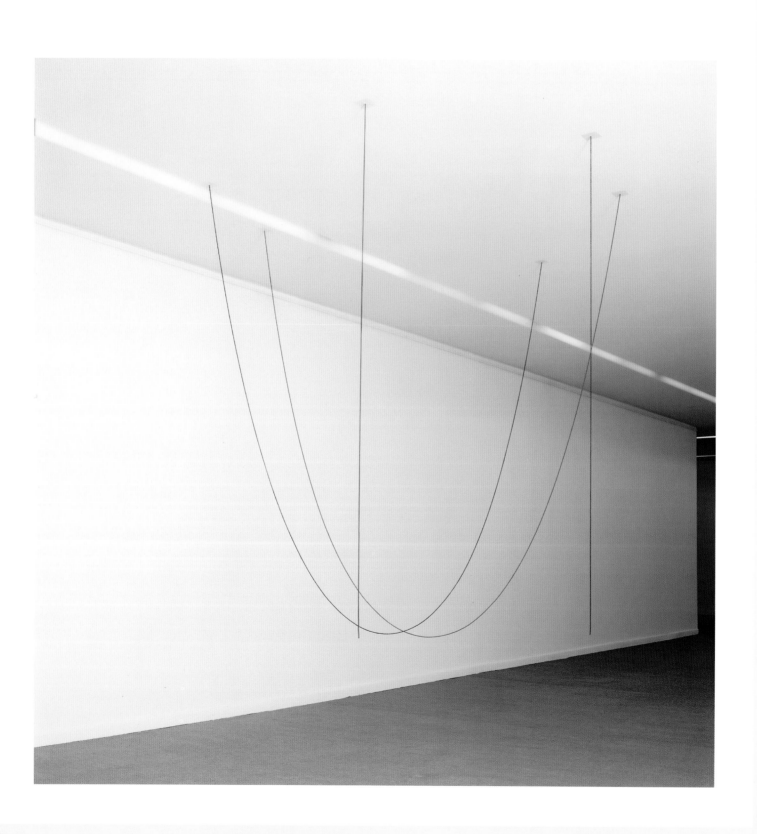

Yet it is real and in front of us, just as the plates that traditionally seem so real are fictions *because* of their verisimilitude. The intricate interplay between reality, fiction, representation, present, and past creates an elaborate web, much like one in a Borges short story, in which the elaboration of a logical conundrum begets a thrilling and engaging intellectual experience.

It would be a mistake to frame a work like *Velázquez* within the institutional critique that was prevalent in the 1990s, when the book was made. Unlike the way in which his peers were working at the time, Caldas set out to pay homage to art history rather than to critique and deconstruct it from a position of superiority. Caldas asks how an artist like Velázquez can continue to pose interesting problems for the contemporary world. The book invites a conversation with the past rather than simply reproducing or commenting on it, and this interaction is what gives the work such power. It is also, incidentally, one of the few works from the 1990s to use Photoshop productively: not to manipulate reality for its own sake, but rather—to paraphrase Picasso—to tell a lie that tells the truth.

The Nearest Air is part of another paradigmatic series for Caldas. Consisting of little more than colored yarn, these works are among Caldas's largest and most impressive. In them, Caldas uses yarn to carve up space, dividing the air into fractional elements that the audience must negotiate. Although at first these sculptures may resemble Fred Sandback's compositions, Caldas's differ in that they are only ever secured to the ceiling, while Sandback's are often anchored into the floors and walls as well. This difference may seem slight, but its effect is critical: whereas Sandback's works rigidly dissect space, creating tension and offering a rigid sculptural analysis, Caldas's sway with the lightest touch. The organic undulations of *The Nearest Air* evoke bossa nova's ease and weightlessness, providing a melodic counterpart to Sandback's rigorously geometric rhythm. Caldas's colored yarn dissects space very seductively, evoking Marcel Duchamp's definition of the "infra-slim," the narrow divide between the smell of cigarette smoke and a smoker's breath. There is no doubt when looking at Caldas's work that the air on one side of the yarn is fundamentally different from that on the other—the sensation is intangible and yet undeniably there.

Caldas's many decades of production present a paradox. Not classifiable as minimal or conceptual, neither installation art nor formalist in conceit, Caldas's work carves out new territory and announces its own terms of engagement. Literary without literature, musical without music, and intellectual without discourse, Caldas presents empty space as an act of resistance, a place in which to think, experience, and, most importantly perhaps, change your mind.

NOTES

1. All quotes from Waltercio Caldas are from conversations with the author conducted over the period 2007–2012.
2. Quoted in Gladys Fabre and Doris Wintgens Hötte, eds., *Van Doesburg and the International Avant-Garde: Constructing a New World* (London: Tate Publishing, 2009), 187.
3. Gabriel Pérez-Barreiro, *The Geometry of Hope* (Austin: Blanton Museum of Art, 2007).
4. Luis Camnitzer, *Conceptualism in Latin American Art: Didactics of Liberation* (Austin: University of Texas Press, 2007), 22–31.

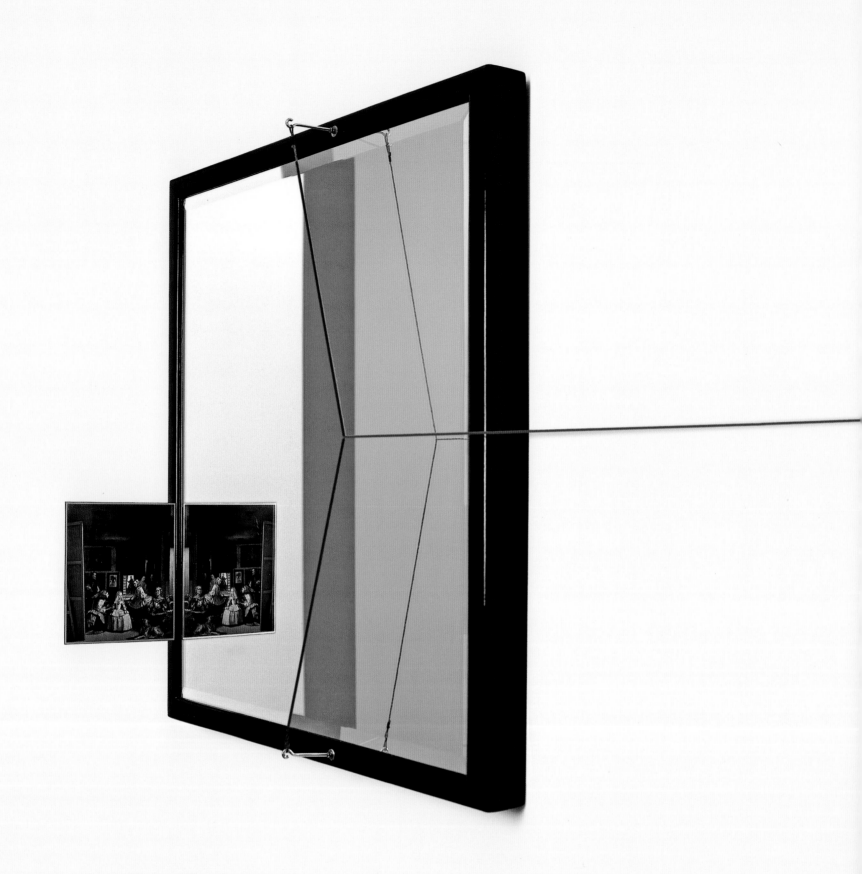

ESPELHO PARA VELÁZQUEZ
(*MIRROR FOR VELÁZQUEZ*), 2000

Framed mirror, cardboard, and yarn
24⅜ × 88⅝ × 5⅞ in. (62 × 225 × 15 cm)

Private collection, Rio de Janeiro

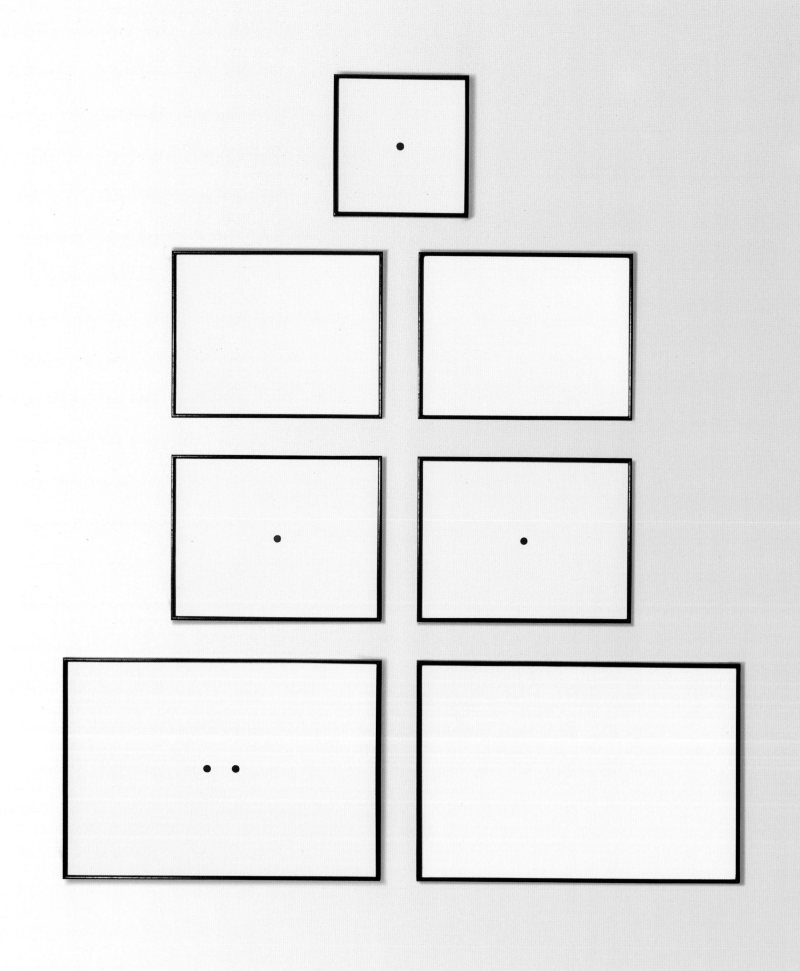

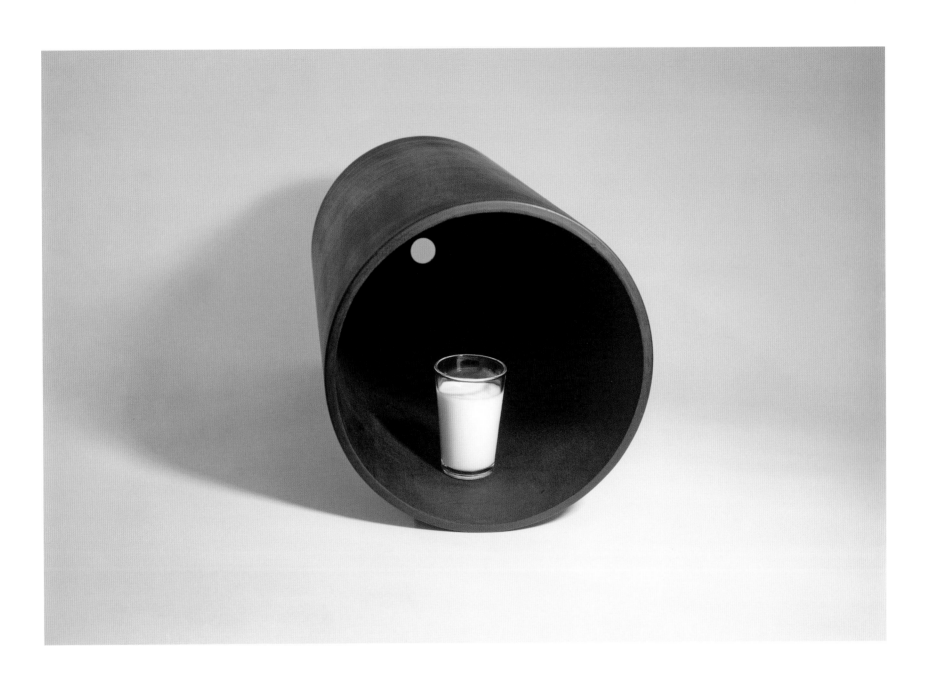

PONTOS (DOTS), 1976

India ink on paper (seven drawings)
61 × 51⅛ in. (155 × 130 cm) overall

Liba and Rubem Knijnik Collection, Porto Alegre

TUBO DE FERRO, COPO DE LEITE
(IRON TUBE, GLASS OF MILK), 1978

Painted iron and glass with liquid acrylic paint
11 × 23⅝ × 11 in. (28 × 60 × 28 cm)

Andrea and José Olympio Pereira, São Paulo

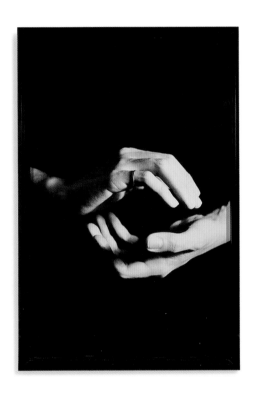 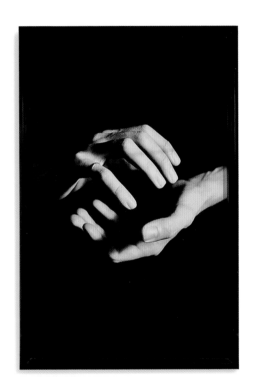

ESTUDOS SOBRE A VONTADE
(*STUDIES ON WILL*), 1975

Suite of five chromogenic color prints
Each 22¹³⁄₁₆ × 14¹⁵⁄₁₆ in. (58 × 38 cm)

Private collection, Rio de Janeiro

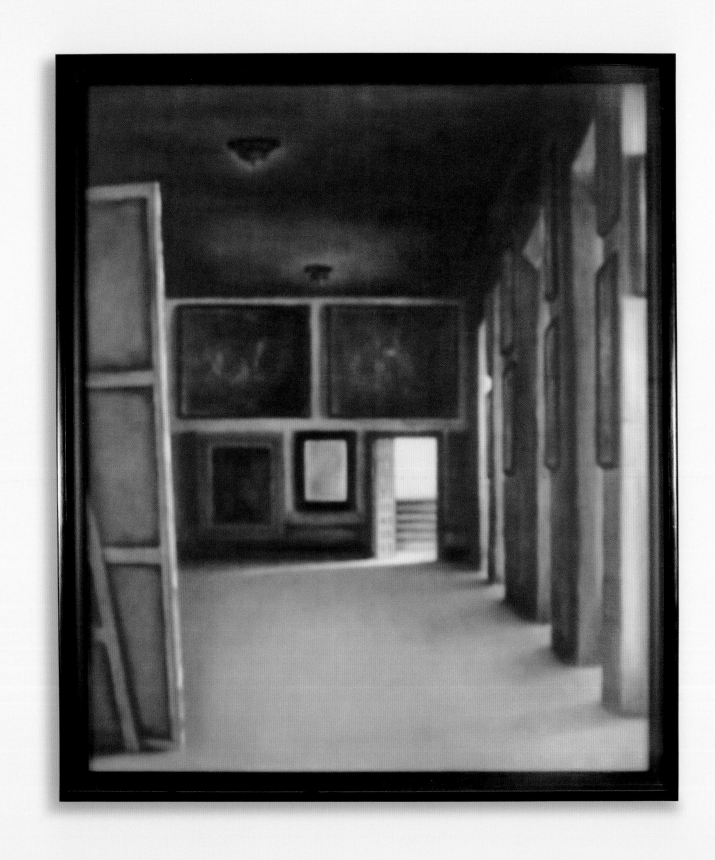

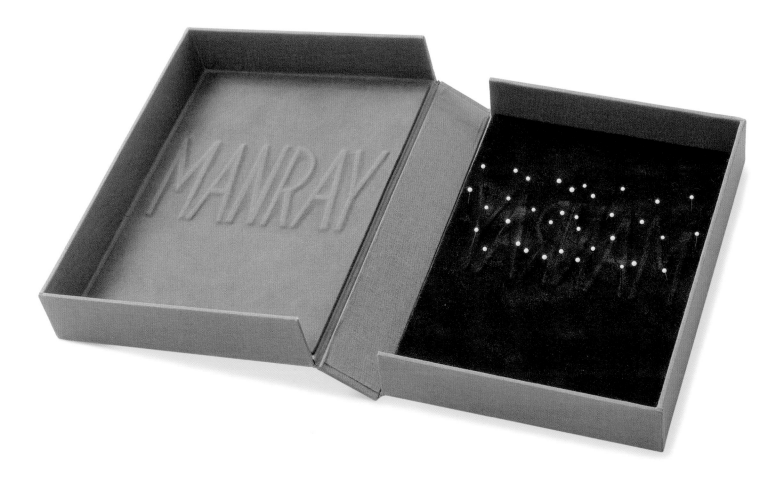

LOS VELÁZQUEZ
(*THE VELÁZQUEZ*), 1994

Digital image on paper, oil stick,
and translucent glass
51 × 43¾ × 2½ in. (129.5 × 111.1 × 6.4 cm)

Colección Patricia Phelps de Cisneros, New York

MAN RAY (*MAN RAY*), 2004

Embossed suede and paper on board, and metal
pins in leather, cardboard, and cloth portfolio
Open: 10 × 16 × 1¾ in. (25.5 × 40.6 × 4.5 cm)

Private collection, Rio de Janeiro

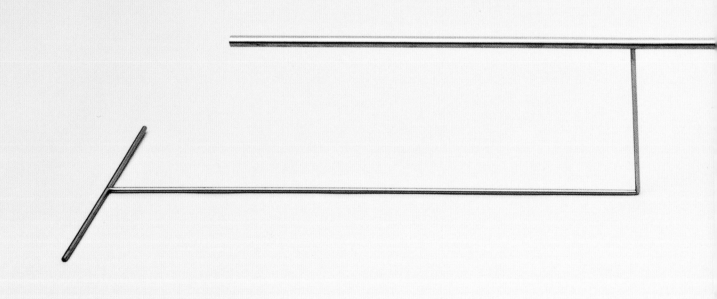

OVO (EGG), 2011

Stainless steel
14³⁄₁₆ × 62⅜ × 7⅞ in. (36 × 159 × 20 cm)

Private collection, Rio de Janeiro

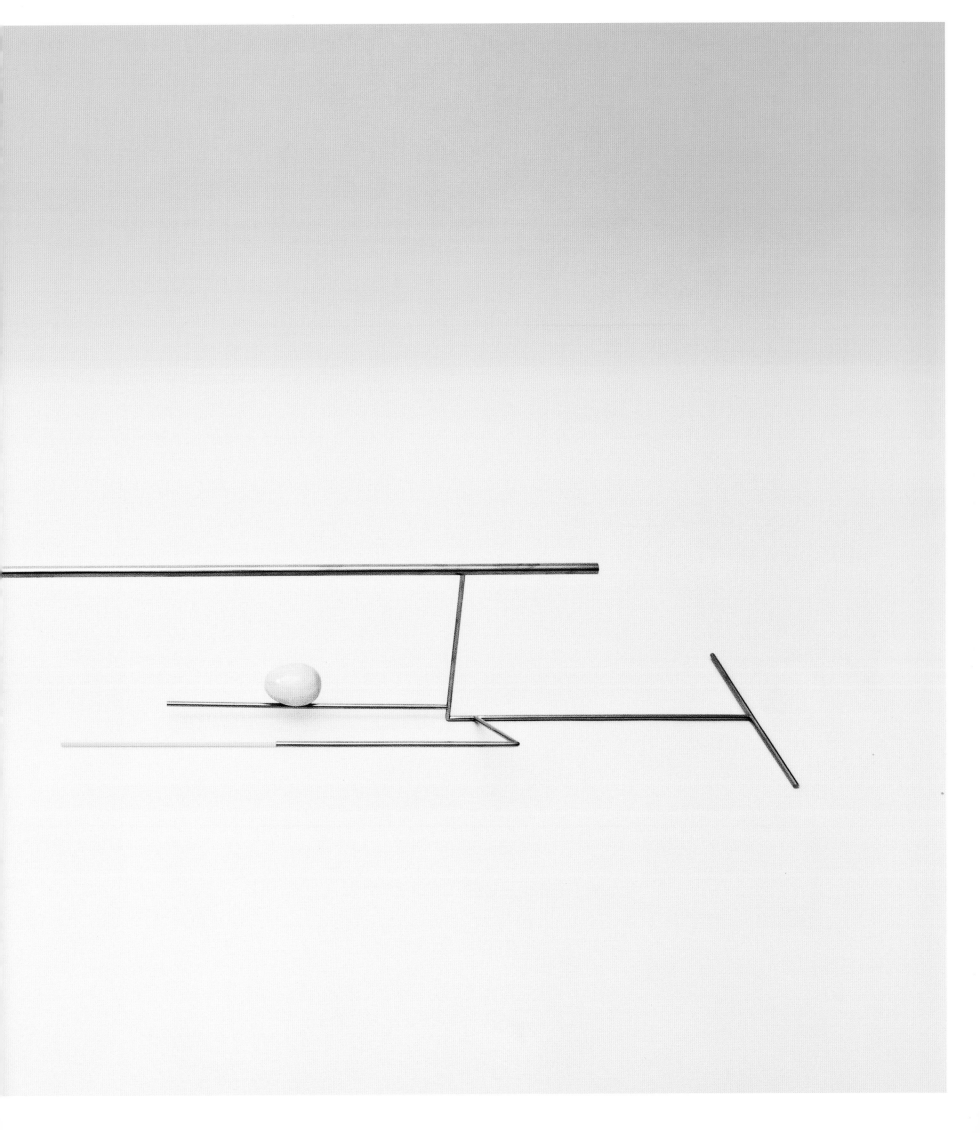

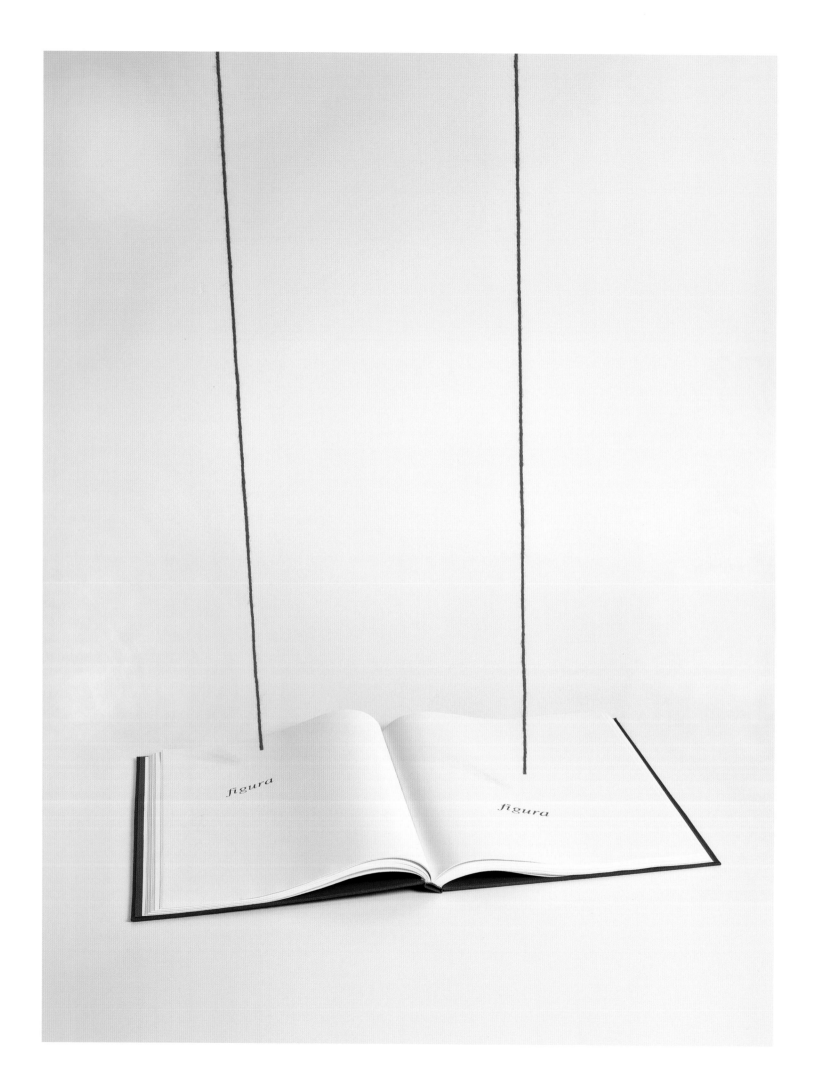

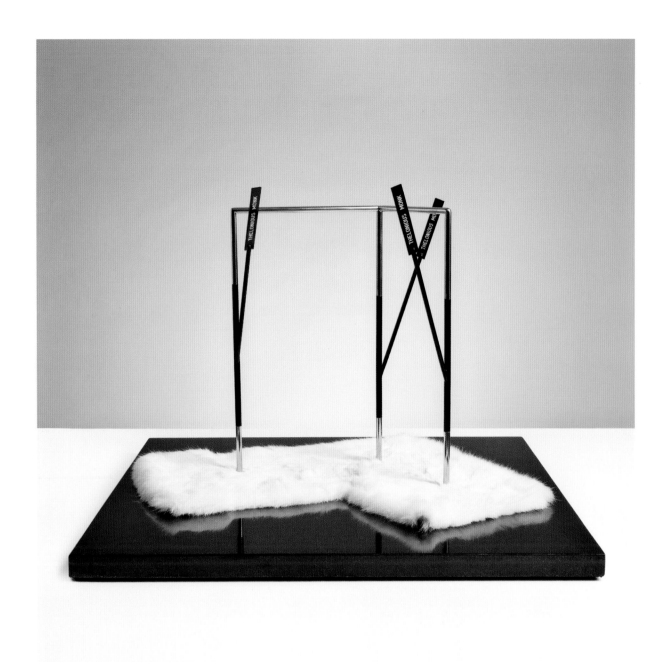

FIGURA FIGURA
(*FIGURE FIGURE*), 1998

Rubber-stamped ink on bound
paper and yarn, edition of 3
35⁷⁄₁₆ × 35⁷⁄₁₆ × 27⁹⁄₁₆ in. (90 × 90 × 70 cm)

Private collection, Rio de Janeiro

THELONIOUS MONK
(*THELONIOUS MONK*), 1998

Stainless steel, acrylic, enamel,
rabbit fur, and granite
27½ × 23⅝ × 22½ in. (70 × 60 × 57 cm)

Private collection, São Paulo

CRONOMETRIA
(*CHRONOMETRY*), 1974

Ink and watercolor on cardboard
17 × 16½ in. (43 × 42 cm)

Private collection, Rio de Janeiro

DESENHO (*DRAWING*), 1975

Ink and watercolor on cardboard
19 ¹³/₁₆ × 14 ¼ in. (50.3 × 36.2 cm)

Private collection, Rio de Janeiro

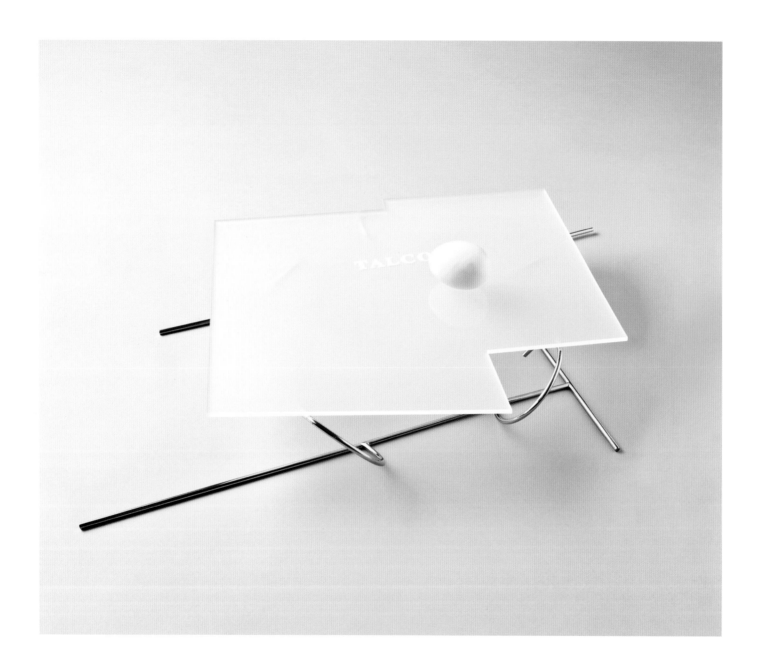

TALCO (TALC), 2008

Marble on acrylic sheet and stainless steel
4¾ × 24 × 14¹⁵⁄₁₆ in. (12 × 61 × 38 cm)

Private collection, Rio de Janeiro

ESPELHO DO JAZZ
(MIRROR OF JAZZ), 2002

Stainless steel, vinyl, and yarn
51³⁄₁₆ × 23⅝ in. (130 × 60 cm)
[variable height]

Private collection, Rio de Janeiro

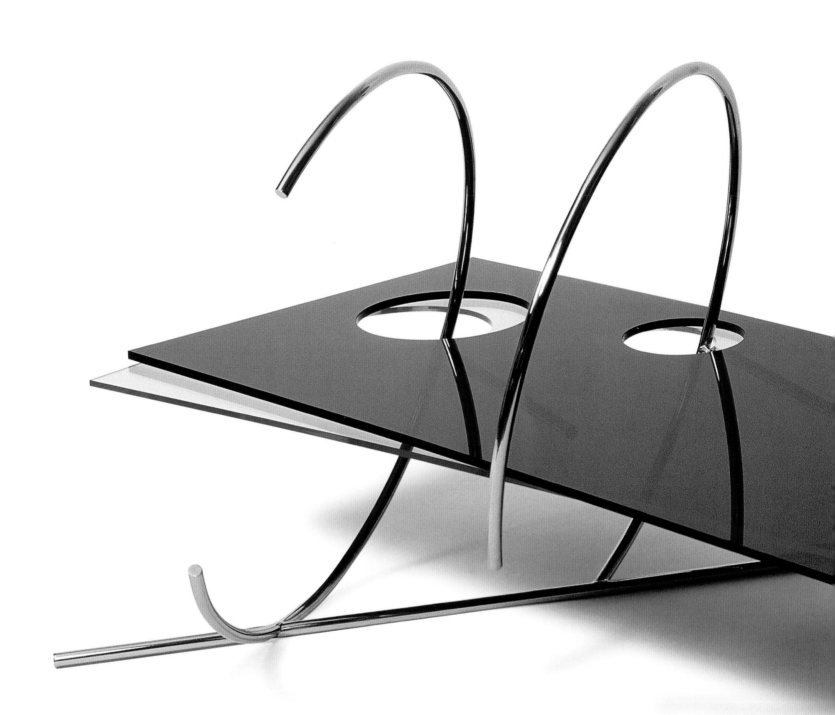

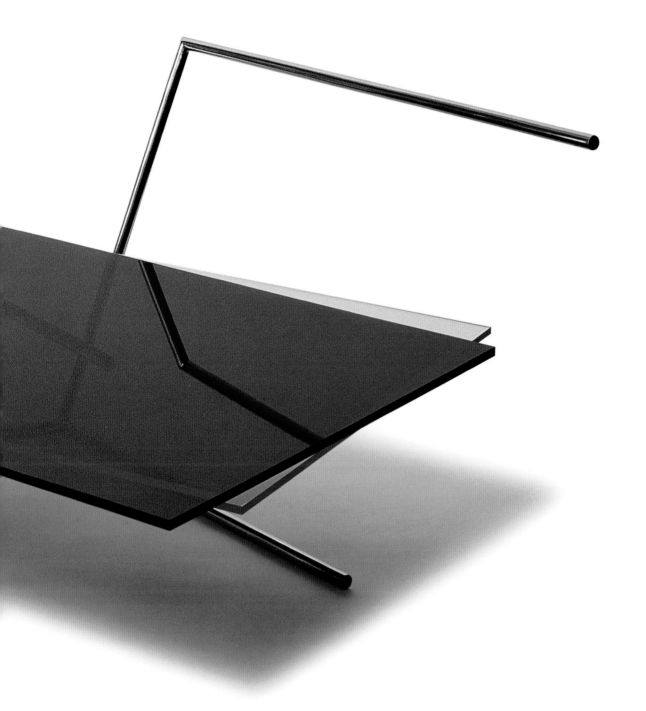

AZUL DE SUPERFÍCIE
(*BLUE SURFACE*), 2005

Stainless steel and acrylic
20½ × 51⅛ × 47¼ in. (52 × 130 × 120 cm)

Andrea and José Olympio Pereira,
São Paulo

DESENHO (DRAWING), 2011

Acrylic paint and resin on cardboard
28¾ × 20 × 3 in. (73 × 51 × 8 cm)

Joana and Thiago Gomide Collection,
São Paulo

DESENHO (DRAWING), 2002

Wood, acrylic paint, and ink on cardboard
19¾ × 27½ × ¹³⁄₁₆ in. (50 × 70 × 2 cm)

Private collection, Rio de Janeiro

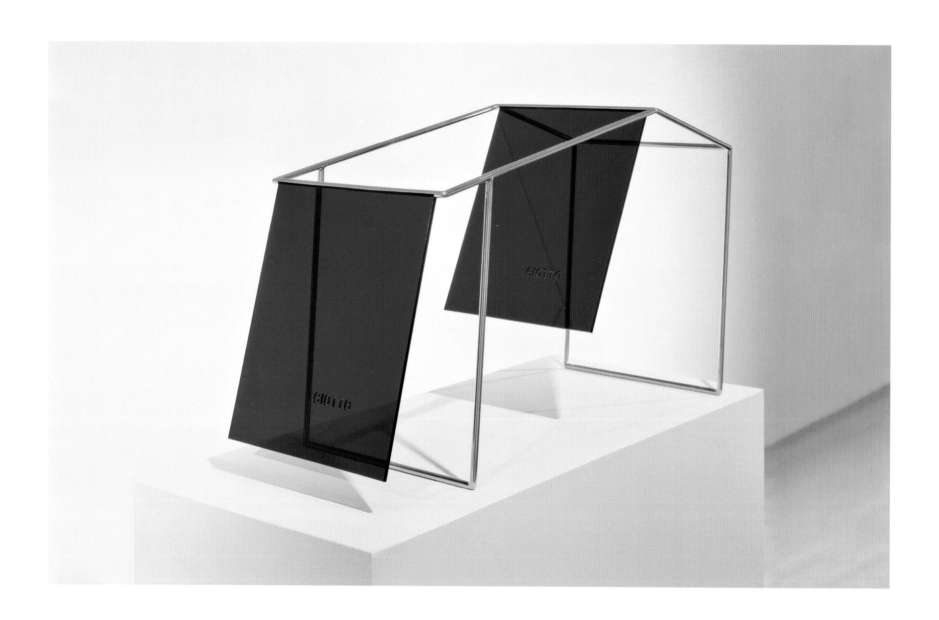

GIOTTO SUSPIRANDO
(*WHISPERING GIOTTO*), 1998
Stainless steel and acrylic plate
19⅝ × 31½ × 13⅜ in. (50 × 80 × 34 cm)

Andrea and José Olympio Pereira, São Paulo

ASAS (*WINGS*), 2008
Stainless steel and wool yarn
94½ × 84⅝ × 17¾ in. (240 × 215 × 45 cm)

Colección Patricia Phelps de Cisneros,
New York

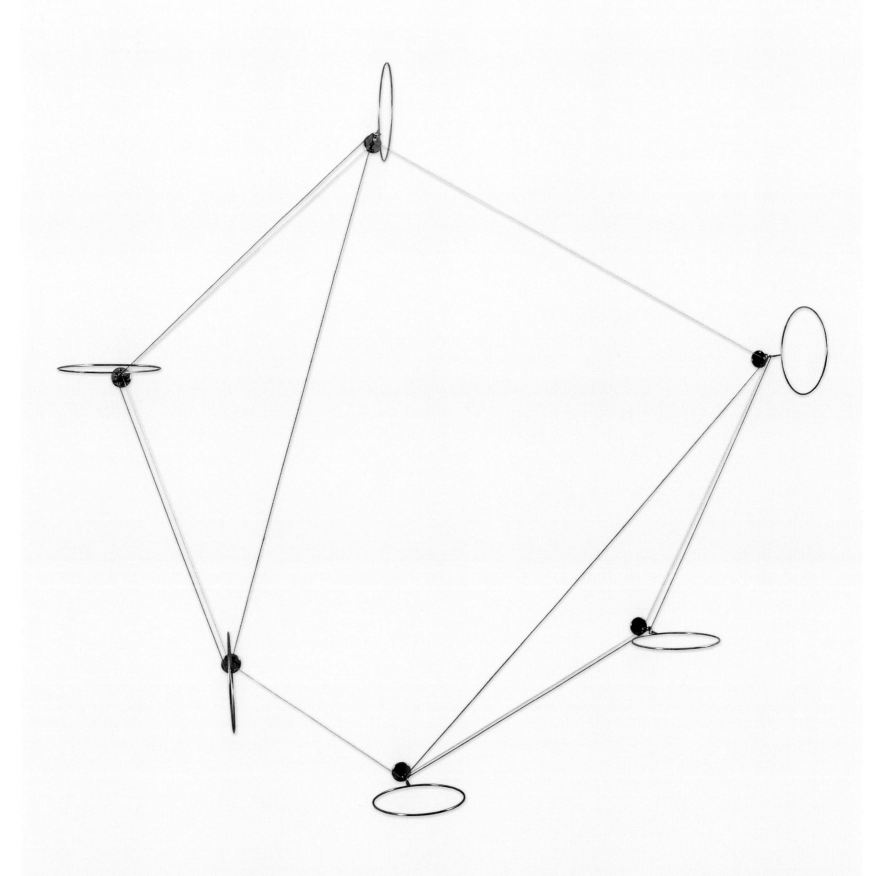

DONDE (WHERE), 2009

Stainless steel, painted aluminum, and cotton yarn
36¼ × 47¼ × 7 1/16 in. (92 × 120 × 18 cm)

Private collection, Rio de Janeiro

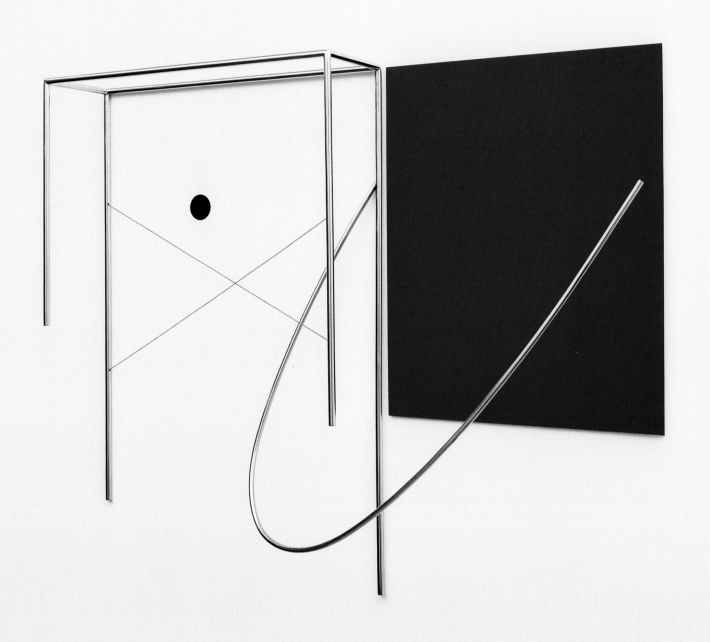

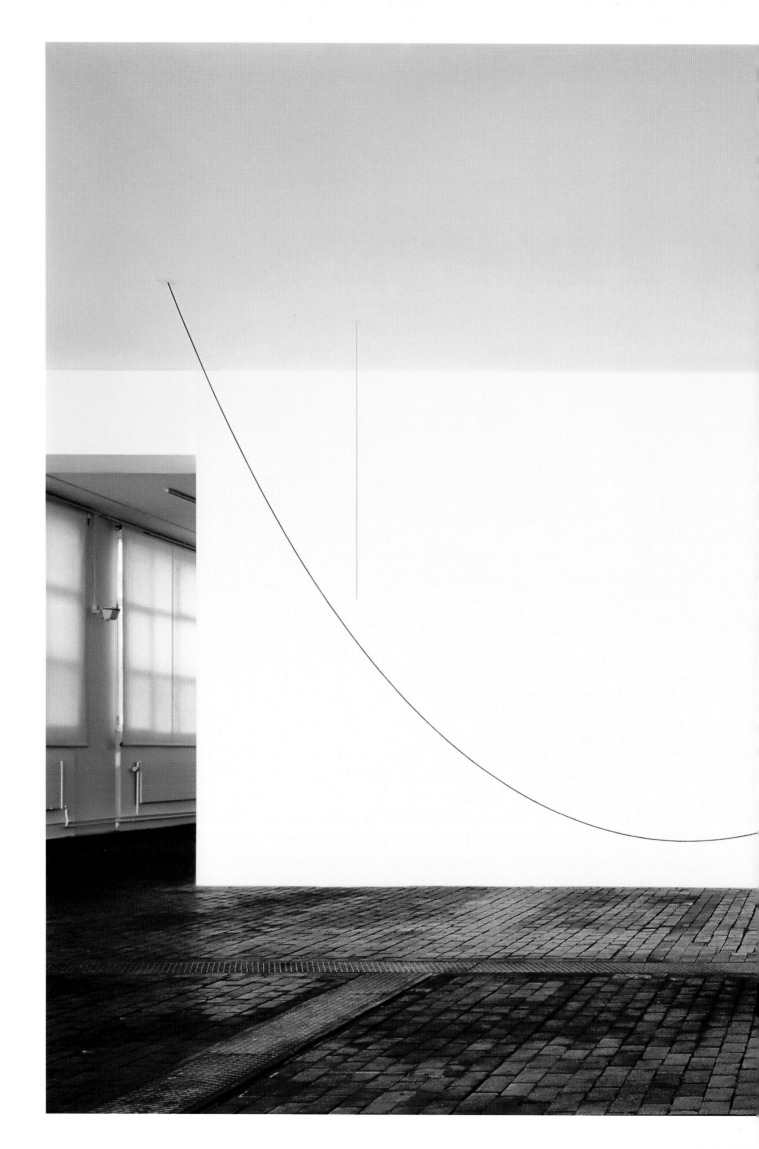

O AR MAIS PRÓXIMO
(*THE NEAREST AIR*), 1991

Yarn
Dimensions variable

Private collection, Rio de Janeiro

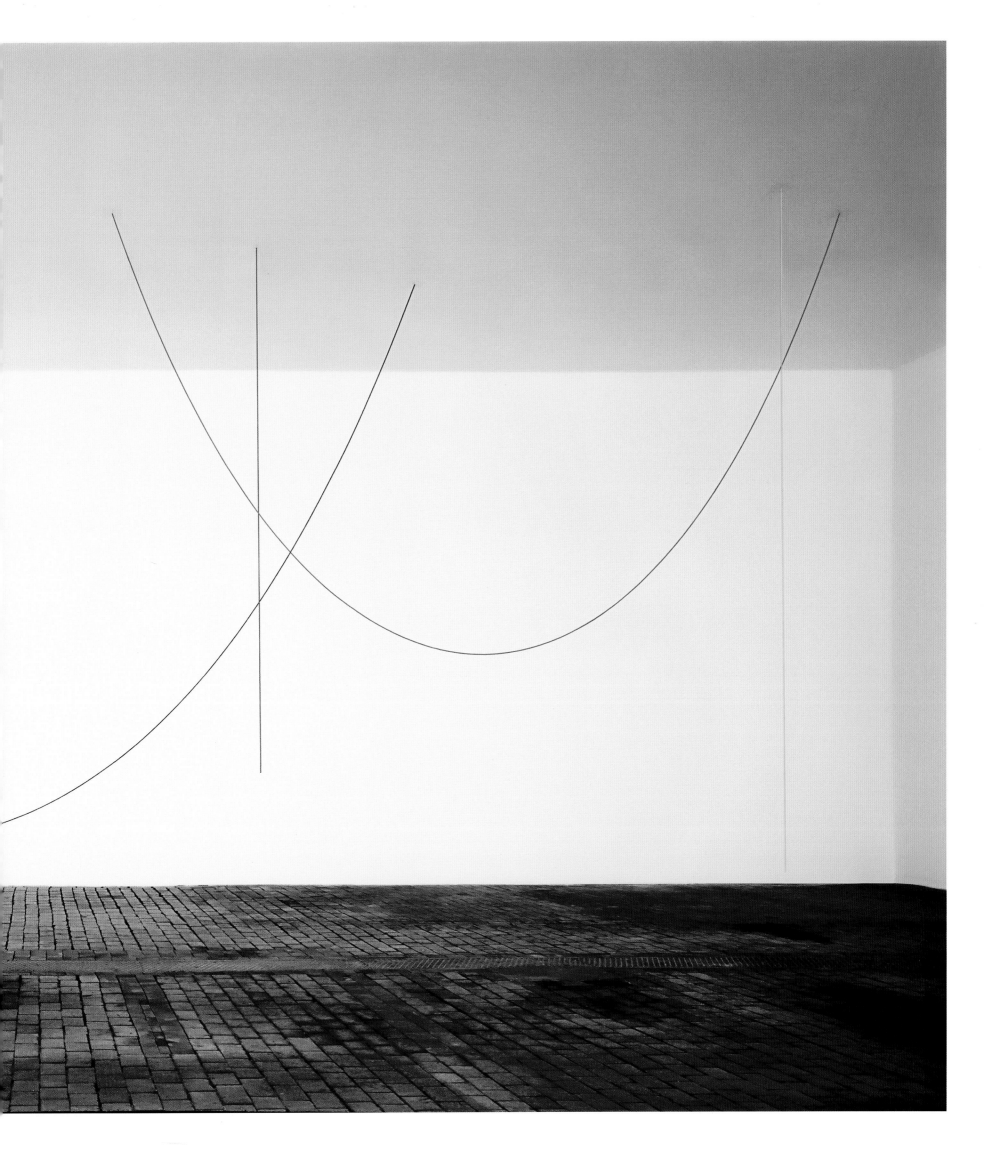

7159

17206

3361048

16110

7656

19

123093

13110

58284

65

465

359

3923

414215

JAPÃO

The *MIRAGE* MAKER

Robert Storr

ABOUT TWENTY YEARS AGO a Brazilian friend gave me a tour of his collection of modern art. It was housed in—better said, stylishly crammed into—a sprawling flat in a modern apartment building in downtown in Rio de Janeiro. Among the things he showed me was a mysterious drawing resembling a map with virtually all the information except a few points of reference eliminated, as if the cartographer had simply removed the contours of the territory that the map was intended to describe and had left indicators where the key cities and towns were located, but with no names attached. This floating constellation of placeless places was surrounded by meticulously inscribed ink borders of several nested thicknesses, in the manner of French draftsmen and printmakers of the eighteenth and nineteenth centuries, giving it a vaguely antiquarian aura despite its otherwise entirely contemporary look, a look familiar to anyone who knows the graphic idioms of conceptual art in the 1960s. When I expressed keen interest in this enigmatic sheet, my friend lit up with enthusiasm—his name is Gilberto Chateaubriand, and an inexhaustible capacity for delight is amongst his great gifts—and told me that he had more where that one came from. Whereupon my friend walked over to an ornate armoire, reached to the top, and pulled down a package loosely wrapped in crumpled paper and done up with string. After untying the knots he extracted the contents, which consisted of dozens of drawings on stiff sheets identical to that on which the mysterious chart had appeared, including two more maps of the same type. The first of the series was labeled *Japão*. The second and third were identified as *Africa* and *India*. All were dated 1972. Several years later the three drawings appeared in *Mapping*, a show I organized at the Museum of Modern Art in 1994, and in due course Chateaubriand donated the group to MoMA, of whose International Council he has long been a

member. Subsequently another work—*Mirror of Light* (conceived in 1974 and fabricated in 1998) followed, thanks to his generosity and that of other friends.

Chateaubriand's trove of drawings was far from being exhausted by this act of patronage. The dozens remaining in the pile after I had set aside the ones cited above were diverse in their imagery, although consistent in their formatting, with the same carefully ruled margins and the same plain but precise descriptive style. Some had a vaguely Pop aspect, but as if Pop had been invented a century or more ago, when fine engraving rather than garish photo-offset printing was the norm. The Belgian trickster Marcel Broodthaers deployed a similar kind of anachronism in order to simultaneously mine and mock Pop from the position of someone living for the most part outside its consumer-culture context. In their sly wit and obviously contrived anomalies, others in Chateaubriand's horde recalled the work of Broodthaers's Brussels-based mentor and goad René Magritte. These graphic caprices displayed a mind at play and, as I recall them, might have led to a neo-Dada career similar to that of the Catalan polymath Joan Brossa and fellow vanguardists from South America and the Iberian Peninsula who have studied Marcel Duchamp's example through the lens of literary Surrealism. Indeed, traces of such a sensibility are present in a number of Caldas's first sculptural objects and survive in his later work, about which more in a moment. But in and of themselves, uncanny sight gags were not Caldas's primary concern at the outset.

Nor have they become so since then. Rather, his art has always pivoted on finely tuned discrepancies between perception and cognition, on calculated incongruities between what we see—or think we see—and what we know—or think we know. In short, his is an art of paradox, of simultaneous perceptual apprehension and conceptual comprehension and of the inevitable short-term and long-term disparities between the two. Yet, in a period when jamming the mechanisms of logical positivism has been standard operating procedure for countless tendencies in the furtherance of whose cause language has taken almost universal precedence over the senses, that is, in a period when the medium as well as the message of conceptual practices has consistently privileged the written word (or what can be said once a form or image has been translated into words) over forms and images as such, Caldas's oeuvre stands out as a series of adroit demurrals in the face of ready-made discourses even as his work consists of compounded but singularly agile and refined expressions of dissent from the conventional wisdom of contemporary academies of thought and taste.

For starters, consider examples from the mid-1970s that seem most easily assimilated into established "neo-Duchampian anti-aesthetics." The amalgam of critical perspectives and creative approaches subsumed by such doubled-down postmodernist jargon has been the predominant—or to use the currently preferred terminology, "hegemonic"—academy of the last third of the twentieth century and into the first

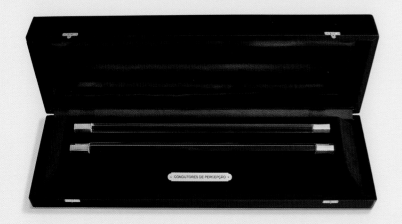

decades of the twenty-first. Essential to that academic ideology is a persistent devalu-ation of both the eye and the hand. That is to say, a downgrading of visual pleasure and a "de-skilling" or subcontracting of studio facture, aimed at undermining the foundations of the "aesthetic" as it has historically come to be understood.

More specifically still, what is meant by the aesthetic in such quarters is a realm of ostensibly disinterested delectation that eschews all questions that might possibly draw attention to the art's epistemological or ontological infrastructure or to the social, economic, or political superstructure erected around it. To be fair from the start, Marcel Duchamp in whose name this academy has long exercised its power, cannot be blamed for the intellectual excesses of dogmatic disciples who have selec-tively appropriated his ideas and grafted them onto others very nearly antithetical to those we know he affirmed. Certainly, Marcel the eternal dandy would have made a very strange faculty colleague and a still stranger fellow cadre in the "Central Com-mittee" of any of the numerous ostensibly revolutionary factions that have tried to posthumously recruit him. But neither are these hybrids to be dismissed out of hand. The deft admixture of Marcel and Marx found in the work of Félix González-Torres and others of his generation demonstrates the merits of such piratical *détournement* while exemplifying the difference between a "strong misreading" of the literature, which can lead to a fresh point of critical as well as creative departure, and a "weak misreading" of the same sources, which often engenders one-size-fits-all categories even as it mandates that whatever cannot be made to fit must be banished from serious scrutiny.

Indeed, it is the narrowness and rigidity of neo-Duchampian anti-aestheticians that makes them such poor guides to so much of the work that has taken inspi-ration from Duchamp's protean perversity—that, and their compulsive insistence that footnoted arguments are more persuasive than experience or revelation. To the extent that González-Torres shows how effective a light touch can be for pinpoint-ing and addressing the weightiest, most vexed political and social issues and the most emotionally charged matters of psychosexual identity, Caldas corrects the anti-aesthetic biases of the neo-Duchampians to a similar degree by pressing the advan-tages of an exquisitely sensual, hyperaesthetic methodology for posing problems that have no answers, at least none that language can be solely entrusted to provide.

Let us return, then, to the earliest phases of Caldas's development as a creator of three-dimensional riddles, for in one form or another riddling is his métier. For our purposes, *Perception Conductors* (1969) is as good a place to start as any. Encased in a hard velvet-lined box of the kind in which one might find surgical or measuring instruments in a medical office or laboratory lie two glass rods capped with silver. How these implements might assist with or enhance perception and which of the senses they might be designed to aid remain entirely open to question. Naturally, metals conduct electricity, and of the readily available kinds, silver is the best. Yet the

caps affixed to each rod are separated in a way that throws that capacity into doubt. Glass, of course, allows for the passage of light and in myth provides a pathway for the spirit as well—God was supposed to have inseminated the Virgin Mary like light passing through a glass vessel. But the intended deployment of the glass shafts Caldas has fashioned (as prisms or lenses) is far from obvious. Thus we are left with teasing pseudoscientific or perhaps magical devices that seem to promise exceptional receptivity yet withhold access to it. And so, by means of beautifully crafted, intensely material objects of uncertain utility, the work induces a waking dream state in which the doors of perception remain ajar, allowing a ray of hope—or subliminal insight—to penetrate the skeptical mind.

This fusion of physical specificity—of which Caldas's emphasis on workmanship is emblematic—and phenomenological uncertainty is present in almost all of the artist's output. *Dice on Ice* (1976), *How Does the Camera Work?* (1977), *Invitation to Reasoning* (1978; see page 77), and *Completely Full Aquarium* (1981; see page xiv) collectively manifest an explicitly surrealist element consonant with his early drawings. *Dice on Ice* in effect preempts or arrests the chance operations implicit in the embedded object and indefinitely suspends them, since the work is a photograph and there is no telling, based on the information it contains, when, if ever, the ice will thaw and the dice will roll again. *Invitation to Reasoning* is a droll "*cervellite*," as Duchamp called "thought objects," perfectly calibrated to stymie rational analysis or interpretation. Accordingly, this invitation to reason is booby-trapped: no logical paradigm will explain why a length of pipe—anticipating by over a decade Robert Gober's equally enigmatic body-traversing conduits—runs through a tortoise shell. Moreover, while the mind struggles to reconcile these incommensurable components, the telescopic qualities of the pipe and the brain-like quality of the shell become increasingly prominent without ever logically accounting for themselves or collaborating to define a literal or metaphoric meaning.

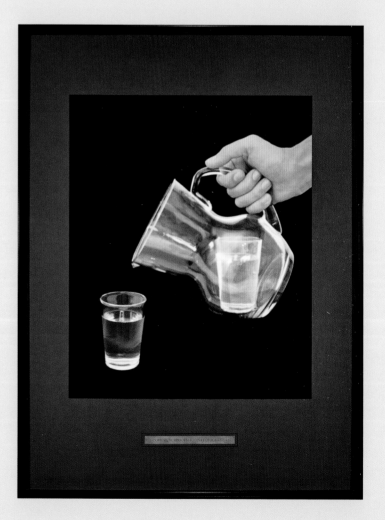

The art of nonsense depends for its dialectical significance upon an unresolvable tension with common sense; the terms of this calculated stalemate require that the irrational variables of the equation be as fixed and memorable as an irrefutable axiomatic truth. In this way, doubling the water glass in *How Does the Camera Work?* conjures up a paradoxical symmetry in which the glass inside the pitcher and the one into which the pitcher is about to pour water stand for two equivalent volumes of a liquid already contained in both but otherwise absent from the pitcher. Double exposure—how the camera works in this instance—would seem to solve the mystery, but the dry pitcher enclosing the ghostly glass destabilizes such a mechanical, consequently reductive reading of the image and returns it to the liminal state described above, the dream state in which logic is not so much violently overturned, as the surrealists were in the habit of doing, as it is subtly inverted for the sake of better, more protracted contemplation. The motive is less to break the rules and create

an abrupt epistemological rupture than to hypothesize an alternate set of rules while whimsically refraining from spelling them out.

A fair amount of Caldas's work makes explicit reference to the art historical past, but does so without the sarcasm typical of so much postmodernist work. Being "post" matters little to Caldas, but annexing modern art to his own territory matters a great deal. In this manner, *Bottles with Cork* (1975) evokes the still lives of Giorgio Morandi but playfully accents the uncanny location of the third cork in the composition, the one to which the title explicitly refers. Instead of sealing its own porcelain flask, that cork plugs the void between the two other flasks, forming a kind of "ready-made" trinity with the "holy ghost" of the missing flask in the middle. The religious analogy may strike some as far-fetched, if not offensive, and it is certainly not my aim to impose Christian iconography on an artist who has given no sign of striving for such symbolism. Still, the abiding issue is that whether holy or unholy, or without any identifiable religious status, we are again in the presence of a ghost image. Approached from art history rather than mysticism, the strangeness of this arrangement refers us to painterly enigmas of the kind the Bolognese master Morandi delighted in when eliding the edges of two or more shapes, rendering it impossible to distinguish between them or between foreground and background, solid and vacuum. Approached from a phenomenological vantage point, the work confronts

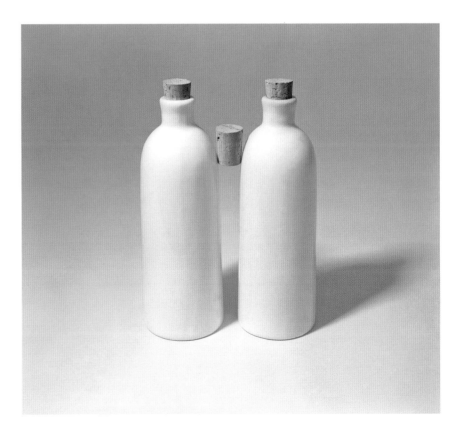

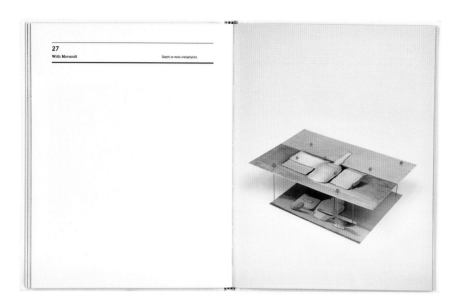

Waltercio Caldas
*MANUAL DA CIÊNCIA POPULAR
(MANUAL OF POPULAR SCIENCE)*, #27

Text by Paulo Venancio Filho. Rio de Janeiro:
Ediçao Funarte, 1982.

us with a disembodied thing resembling a body that, by virtue of its absence, reminds us of our presence and therefore of our bodily self-awareness and "thingness."

That Morandi is in fact a key figure in Caldas's mind is demonstrated by a work that appears as Plate 27 in the artist's book *Manual of Popular Science*. There one sees reproductions of two still lives by Morandi pinned one above the other like a game of double-decker chess or a floating relief by Jesús Rafael Soto laid flat. Doubtless alert to the affinity between Morandi and Giorgio de Chirico, Caldas has subtitled this optically open lamination of two small Morandi canvases as a "sketch on meta-metaphysics," evoking the Platonic assumption that for every physical object within our realm of experience another comparable metaphysical object exists on a higher plane. Except that in this piece, the pins do not align the forms in the two paintings but merely indicate that the flux they describe shares a common matrix, a common reality.

Further exegesis of individual pieces in *Manual of Popular Science*—where all those described so far can be found—is unnecessary. I am avoiding the temptation to elaborate on the basic points I have made so far, because I am leery of proposing restrictive interpretations of works that defy explanation due to their inherently ambiguous nature. What can be addressed is the formal evolution of Caldas's work and the implications of the changes that have gradually been brought about between dense "*cervellités*" and light, expansive, generally open constructions and installations. One of the largest of these was created for the 2007 Venice Biennale at my invitation, and I use it as a key to the others made before or since its realization.

Composed of lengths of hanging threads, sheets of glass inserted at right angles into the walls like partitions, metal armatures extending out from the wall, rectangles

*MEIO ESPELHO SUSTENIDO
(HALF MIRROR SHARP)*, 2007

Stainless steel, glass sheets, vinyl, yarn, and stones
114³⁄₁₆ × 275⁹⁄₁₆ × 70⅞ in. (290 × 700 × 180 cm)

Private collection, Rio de Janeiro

*SÉRIE NEGRA A MÁQUINA
(THE BLACK SERIES,
THE MACHINE)*, 2005

Black granite, stainless steel, and wool yarn
70⅞ × 51⅛ × 137⅘ in. (180 × 130 × 350 cm)

Private collection, São Paulo

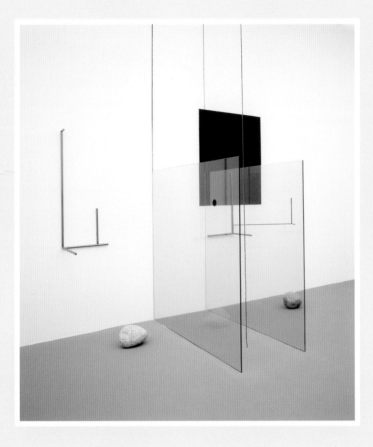

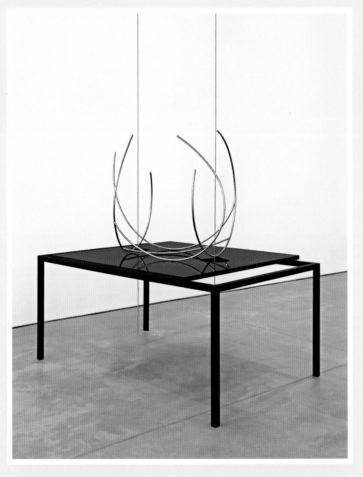

and dots on the wall, and stones on the floor, *Half Mirror Sharp* came together around the ambulatory spectator like a room-sized space frame or a walk-in prism. Every element occupied its place both as an objective reality and as a marker or reference point for looking past it toward another such element; none existed for itself alone, and none was subordinated to another, "more important" element. Moreover, in such a context the barrier to an equalizing of parts that might reduce all to an instrumental status in relation to the composition of the whole was the striking uniqueness of each part, that uniqueness owing to the quirky articulations of metal bars bent into functionless brackets, or to the exact placement or proportions of plate glass, a black dot, or a rectangle, or to the distance from the wall of a dangling red thread. The precision with which each of these parts was conceived and executed—the individuating craft referred to before—is the correlative of Caldas's careful arrangement of this to that. Both preoccupations serve to differentiate his work from North American–style modular minimalism, while the work's environmental dimensions differentiate it from the twentieth-century constructivist aesthetic that it may superficially resemble. The result, like much of his work, is a kind of expansive, dissolving maze, a demonstration of "now you see it, now you don't" sleight of hand and eye.

Caldas's essentially pictorial approach nevertheless aligns him with Constructivism in the same degree that it, along with his painstaking refinement, separates him from Minimalism. But that alignment does not raise the specter of modern design and machine-age dynamics in ways characteristic of Constructivism before 1945—*The Black Series, The Machine* (2005) shows just how far from the latter he has come—or the specter of the "pure opticality" or quasi-scientific system building typical of constructivist tendencies after 1945.

It is just such a pictorialism that gives rise to works such as *The Black Series, Still Life* (2005; see page 79), a setup of wineglasses with a window between them that passes from above to below the tabletop; *Eureka* (2001; see page 63), which may easily be viewed as spatial armature awaiting a painting; or *The Transparent, from the Venice Series* (1997; see page 45), which reads as a Morandi-esque still life delineated in a volumeless three dimensions. Moreover, it is a pictorialism that dates further back to *Thelonious Monk* (1998; see page 19), a panel painting in stone, fur, steel, enamel, and acrylic; to *Whispering Giotto* (see page 30), another of the same year in steel and acrylic plate; to *Plato* (1996; see page 75), a binocular mirror in steel; to *Trombone* (1993; see page 44), a diagram in rare woods; to *Art Apparatus* (1978; see page 49), a pane of glass on a tripod; to *Circle with Mirror at 30°* (1976; see page 59); and to the aforementioned *Mirror with Light* (1974; see page 60), which captures the viewer in a self-regarding gaze while complicating his or her experience with a red warning light that establishes the surface of the "picture plane" as a danger zone

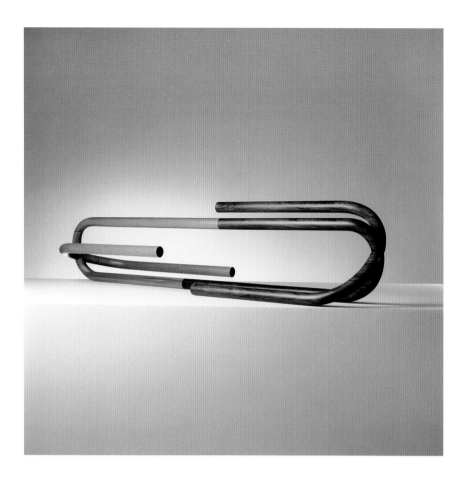

TROMBONE (TROMBONE), 1993

Carved mahogany and imbuya wood
13¾ × 36¼ × 9⅞ in. (35 × 92 × 25 cm)

Ricardo Rego Collection

between the viewer and his or her reflection. And then there are Caldas's homages to painters: his partially "erased" version of *Las Meninas, The Velázquez* (1994; see page 14) and *The Velázquez Book* (1996; see page 5), as well as his four rubber-stamp-on-cotton objects from 1995—*Braque, Picasso, Mondrian*, and *Rodin* (see pages 50–51), the last being the only sculptor represented in the group.

In sum, Caldas's frame of reference—excuse the unavoidable pun—has over and over again been that of a two-dimensional mimetic art—painting—in dialogue with three-dimensional abstract sculpture and installation. In the literature on Caldas, the work of Maurice Merleau-Ponty—a disciple of both Edmund Husserl and Karl Marx—has been frequently invoked. Justly so. But in evaluating these interpretations and the overall reception of Caldas's work both inside and outside Brazil, allowances must be made for cultural differences between the art worlds of North and South America in this respect. In the United States since the 1970s, the conversation about Merleau-Ponty and phenomenology has tended to focus almost entirely on his observations about the mobile spectator and his or her shifting perspectives in relation to sculpture. Prior to that time it had been largely subsumed by the flux of Existentialist criticism—much of it devoted to the concept of painting

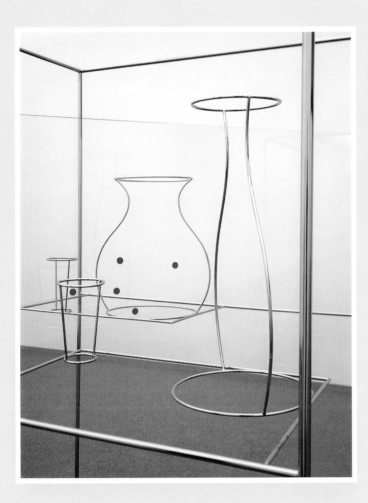

*O TRANSPARENTE, SÉRIE VENEZA
(THE TRANSPARENT, FROM
THE VENICE SERIES)*, 1997

Stainless steel and glass
78¾ × 59 × 59 in. (200 × 150 × 150 cm)

Colección Patricia Phelps
de Cisneros, New York

as a struggle—with which Merleau-Ponty was associated due to his affiliation with Jean-Paul Sartre and their joint editorial roles at the journal *Les Temps Modernes*. With regard to the second wave of enthusiasm for Merleau-Ponty's work, his magnum opus, *The Phenomenology of Perception* (1945), was a primary source for writing on minimalist and postminimalist work, notably by Rosalind Kraus and her followers. However the bulk of the essays by these critics and others caught in their slipstream displayed a pronounced hostility to painting, at least when it came to examples that they judged beyond the pale of a narrowly defined and sanctioned concept of modernism and of the medium itself—after which painting was taken to be an anachronism.

The Merleau-Ponty who applies to Caldas is a simultaneously analytic and synthetic thinker whose project bypasses dogma-driven disputes over art's "necessary" next step and instead encompasses both the basic dialectical model of apprehension and appreciation set forth in *The Phenomenology of Perception* and the nuanced intuitions of the "close reader" of paintings who penned *Eye and Mind* and *Cezanne's Doubt*—in short, a Merleau-Ponty unconcerned with the antipainting teleologies of mid to late twentieth-century formalism in the United States. An avid responsiveness to experience and an unshakable respect for the fundamental contingency of being and meaning are at the core of Merleau-Ponty's writings on art and psychology. A congruent set of concerns are likewise at the center of Caldas's materialized (rather than dematerialized) and skilled (rather than de-skilled) meditations on aesthetics, concerns that have simultaneously led the artist to violate the anticonceptual taboos of conservative "Beauty Brigade" critics who crave sensory pleasure but resent any forms of it that tax the intellect.

Inasmuch as these concerns redirect our attention to questions that have been scornfully set aside or "answered once and for all" by much of the North American critical establishment in recent decades, Caldas's art constitutes a test of just how ready North American audiences are to engage with work that lacks a ready-made discourse, of how willing they are to think or rethink the unthinkable in light of a cultural Otherness that does not declare itself in terms of obvious ethnic or national "difference" but nevertheless subtly makes its differences of origin, context, and intent felt in every dimension of the work at hand. Thoughtful people hungry for a fresh take on the primary but inexhaustible paradigms that have been the predicate of the Western tradition should welcome the challenge to them that Caldas offers and savor the elusive delights he provides. For if art often seems to be a mirage to the same degree that Japan, India, and Africa were phantoms in the maps Caldas drew in 1972, it—like they—nevertheless acquires substance and definition through the collaborative engagement between the maker and the viewer. Caldas has done and keeps doing his part; it is up to those eager to reset the compass of their own minds to do theirs.

ROBERT STORR

DADO NO GELO (DICE ON ICE), 1976

Chromogenic color print in lightbox
29½ × 27½ × 3¹⁵⁄₁₆ in. (75 × 70 × 10 cm)

Private collection, Rio de Janeiro

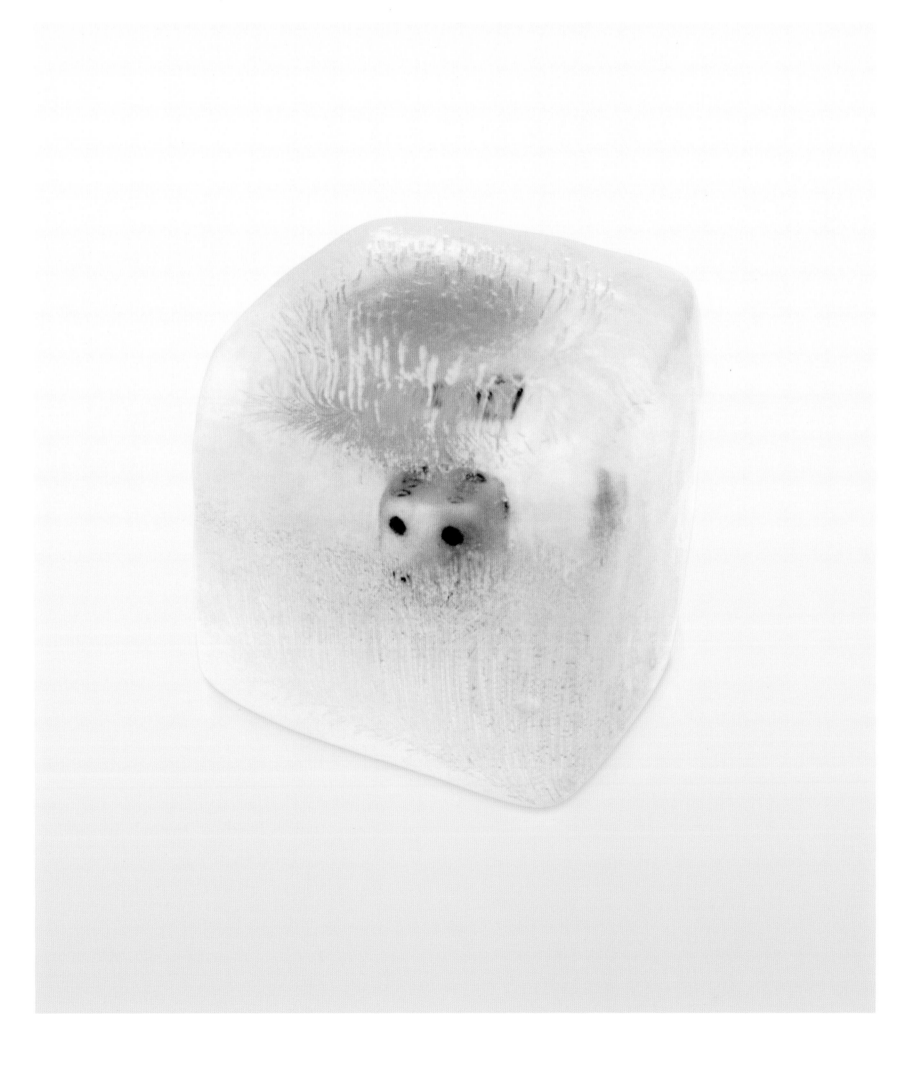

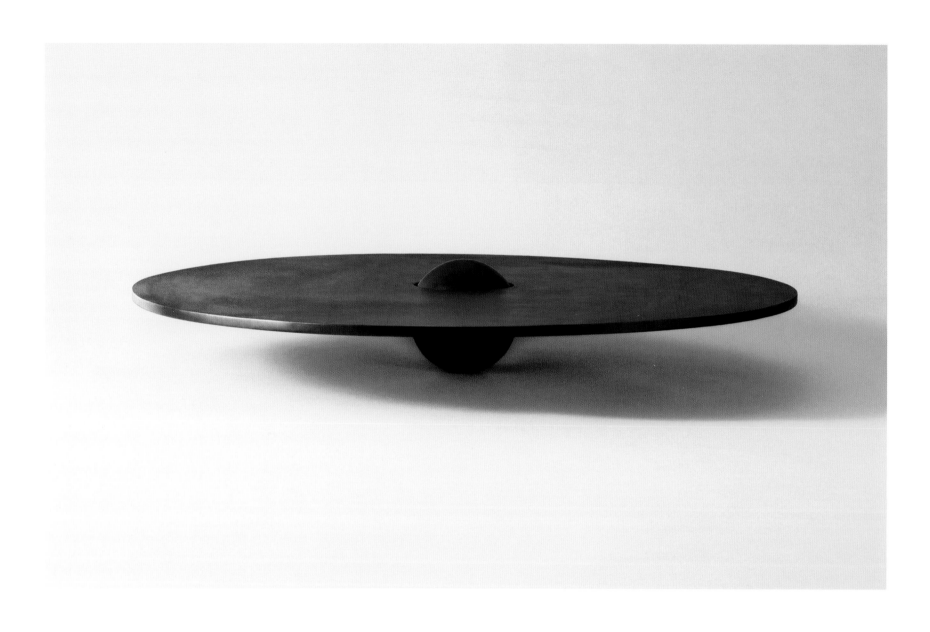

LOGO (*AT ONCE*), 1982

Acrylic on iron
5⅞ × 27½ × 27½ in. (15 × 70 × 70 cm)

Andrea and José Olympio Pereira, São Paulo

APARELHO DE ARTE
(*ART APPARATUS*), 1978

Painted iron and glass sheets
78⅞ × 35⅜ × 35⅜ in. (200 × 90 × 90 cm)

Andrea and José Olympio Pereira, São Paulo

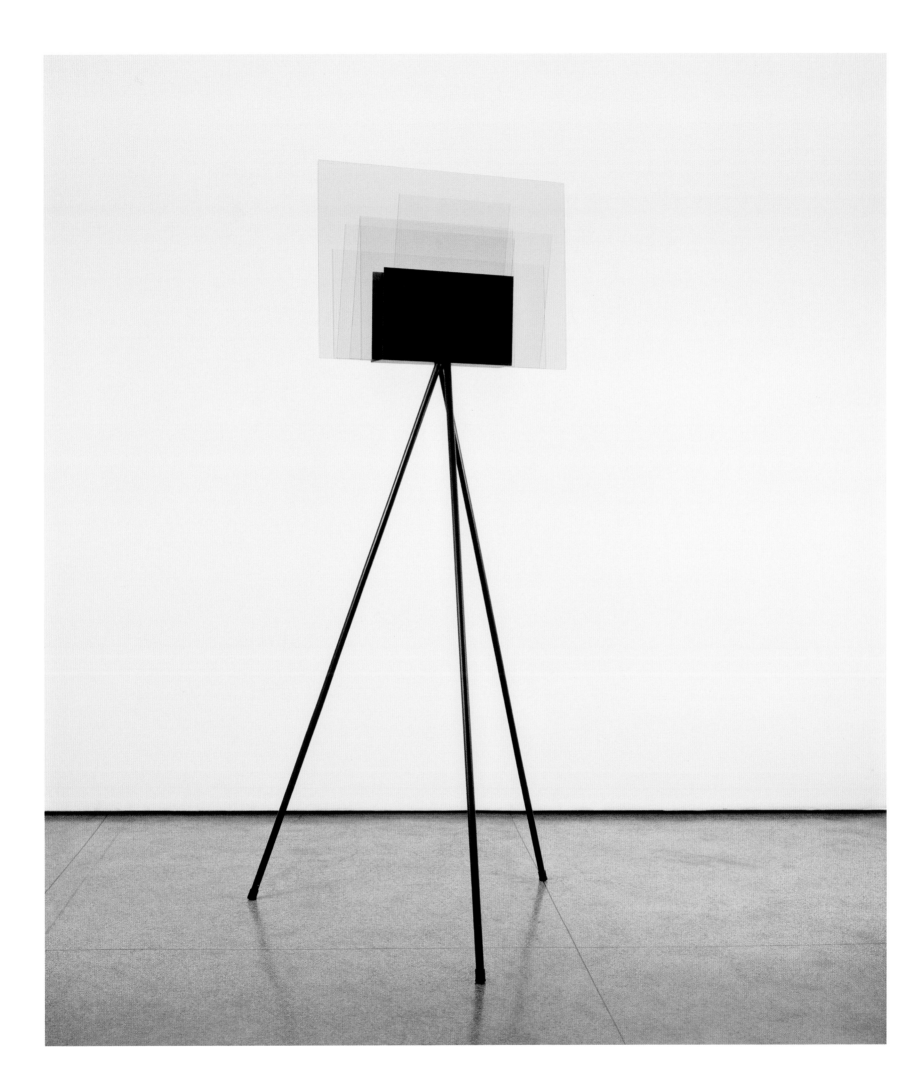

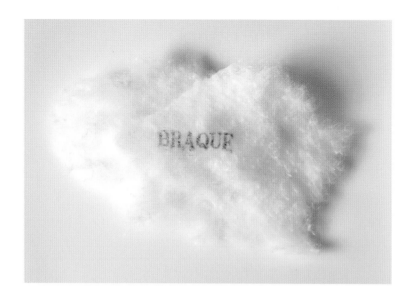

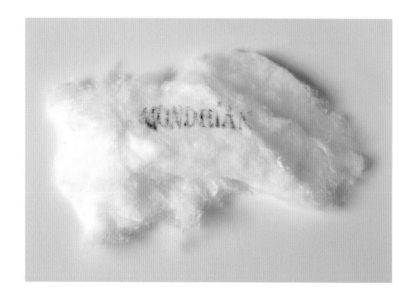

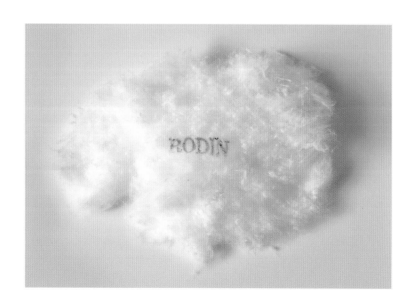

BRAQUE (*BRAQUE*), 1995

Rubber-stamped ink on cotton
15¾ × 11¾ × 2⅜ in. (40 × 30 × 6 cm)

Private collection, Rio de Janeiro

MONDRIAN (*MONDRIAN*), 1995

Rubber-stamped ink on cotton
15¾ × 11¾ × 2⅜ in. (40 × 30 × 6 cm)

Private collection, Rio de Janeiro

RODIN (*RODIN*), 1995

Rubber-stamped ink on cotton
15¾ × 11¾ × 2⅜ in. (40 × 30 × 6 cm)

Private collection, Rio de Janeiro

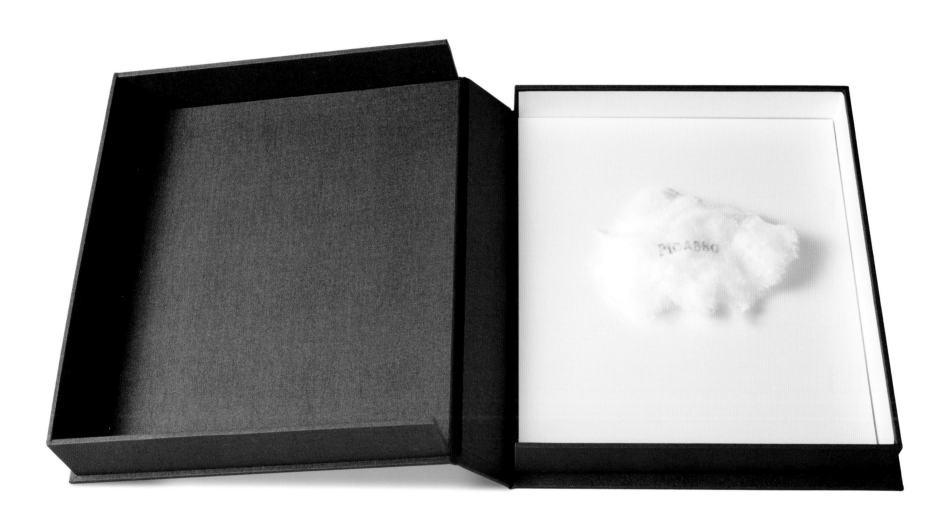

PICASSO (*PICASSO*), 1995

Rubber-stamped ink on cotton

15¾ × 11¾ × 2⅜ in. (40 × 30 × 6 cm)

Private collection, Rio de Janeiro

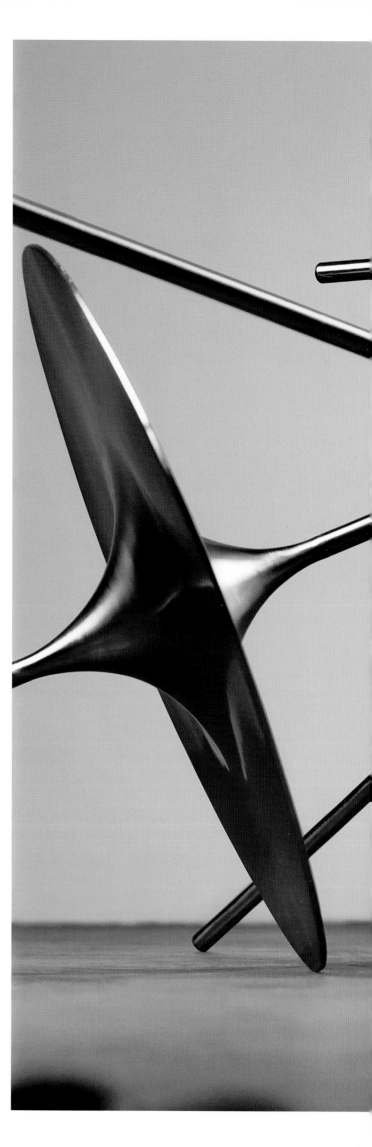

PRÓXIMOS (THE NEXT), 1991

Stainless steel
Dimensions variable

Private collection

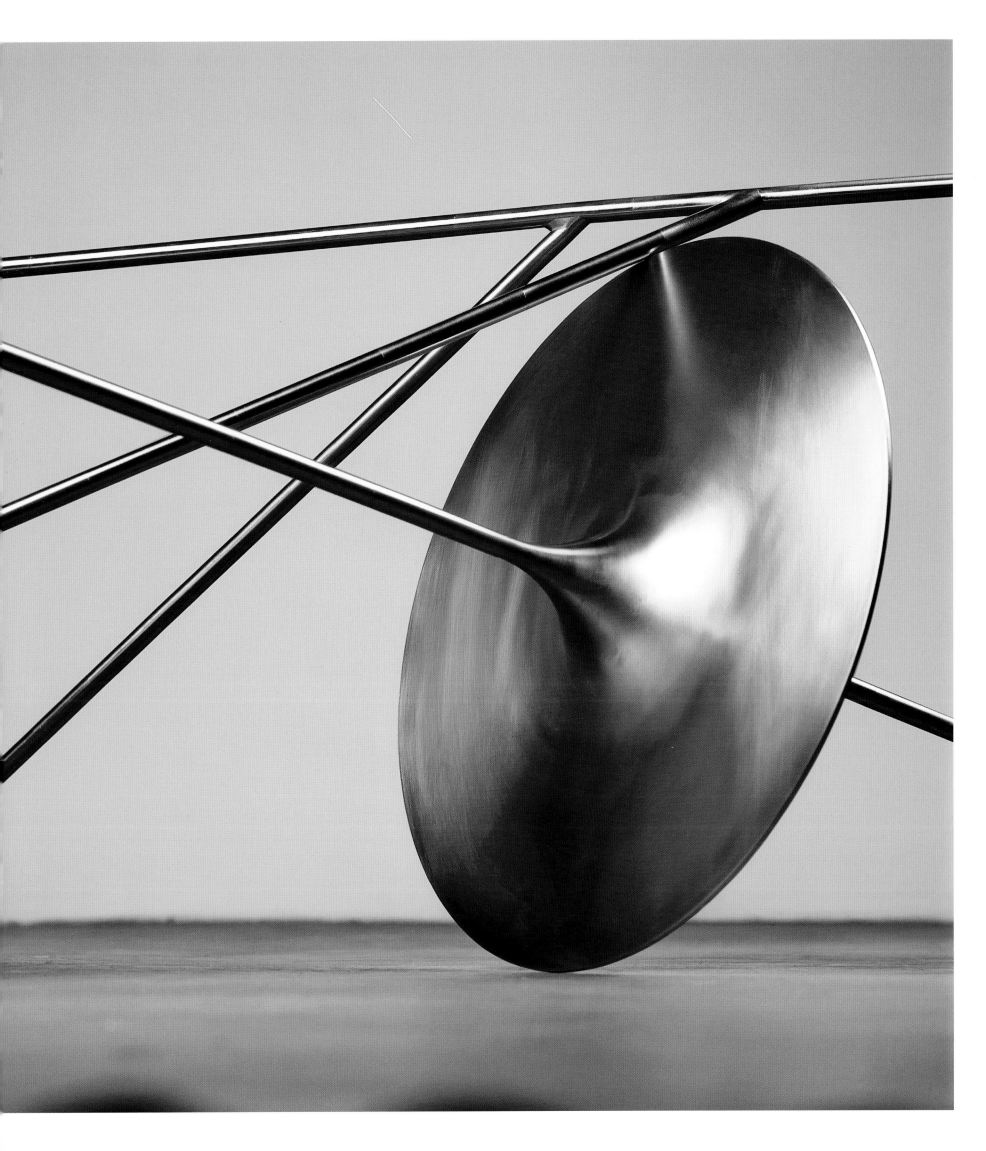

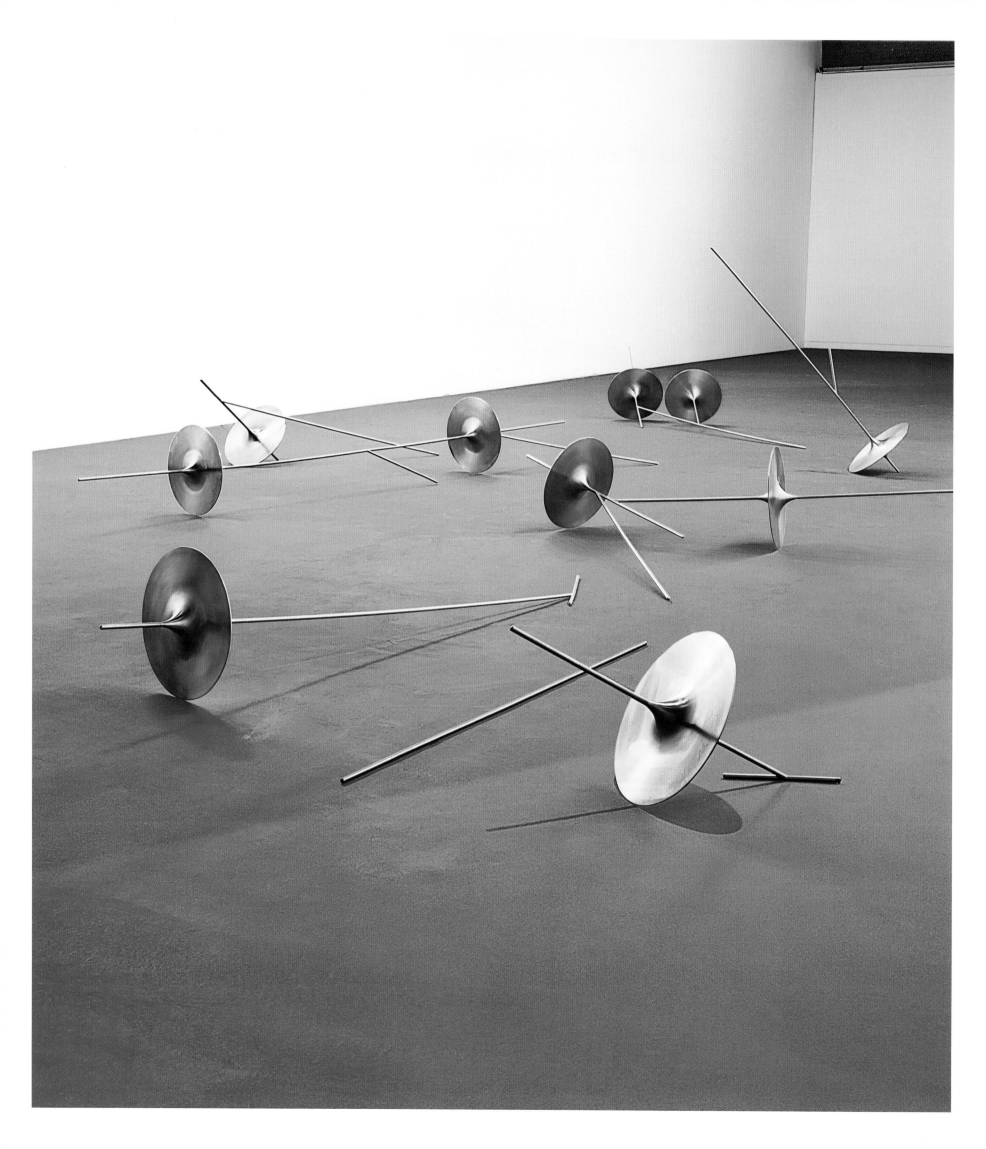

O LOUCO (THE MADMAN), 1971

Lead figurine in velvet-lined box
2⅜ × 31⅞ × 3⅛ in. (6 × 81 × 8 cm)

Gilberto Chateaubriand MAM RJ Collection

ESCULTURA EM GRANITO
(*GRANITE SCULPTURE*), 1986

Black granite
4 × 19⅝ × 15¾ in. (10 × 50 × 40 cm)

Blanton Museum of Art
Purchased as a gift of Margaret McDermott
in memory of Barbara Duncan, 2005

CIRCUNFERÊNCIA COM ESPELHO A 30°
(*CIRCLE WITH MIRROR AT 30°*), 1976

Painted iron and mirror
47¼ × 47¼ × 3⅛ in. (120 × 120 × 8 cm)

Ricardo Rego Collection

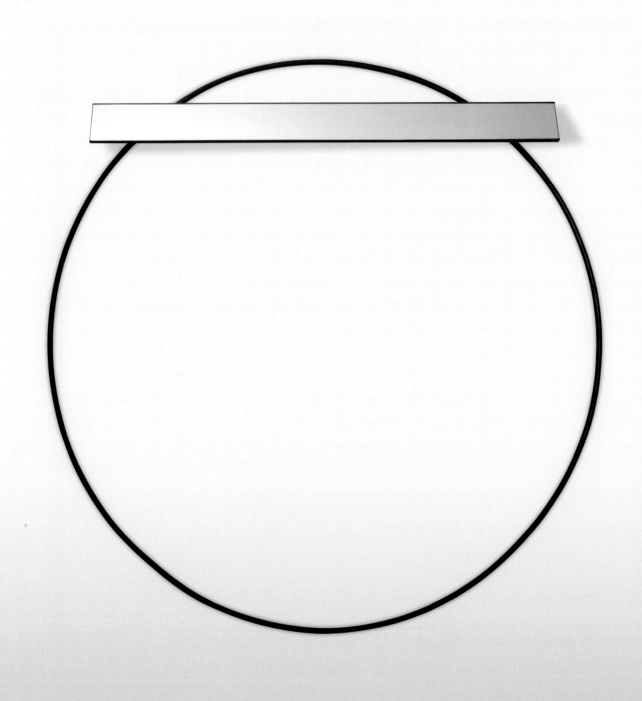

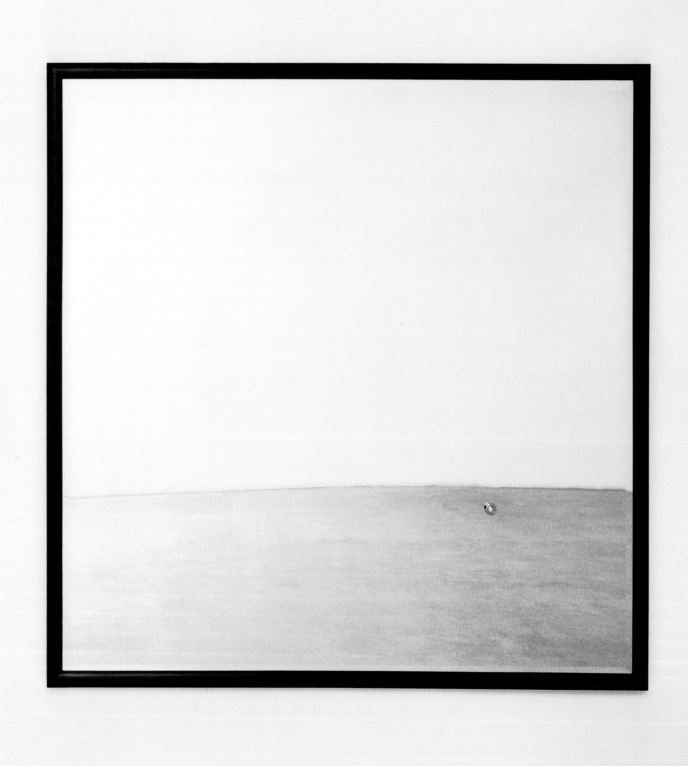

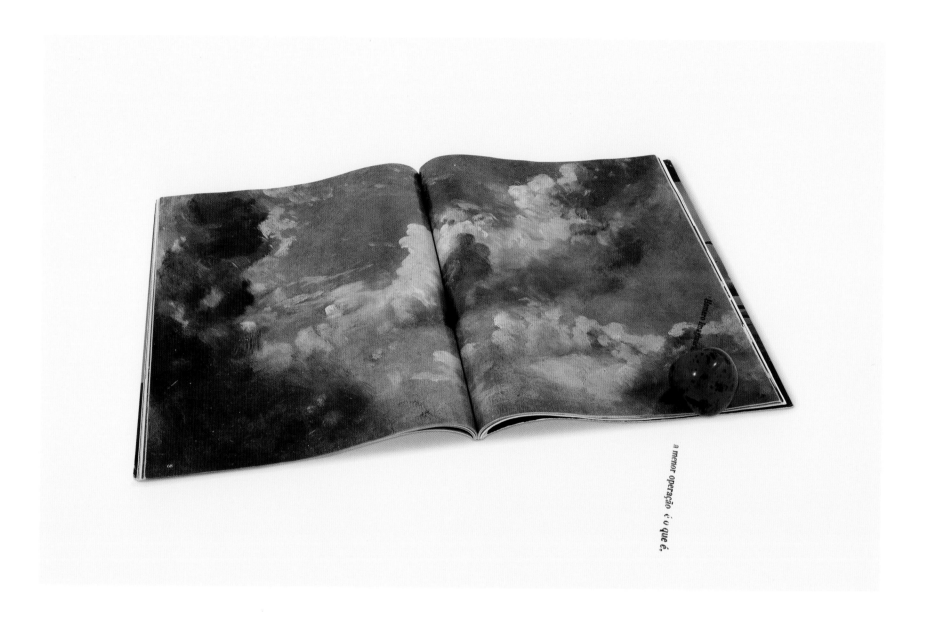

ESPELHO COM LUZ
(*MIRROR WITH LIGHT*), 1974

Frame, mirror, and backlight
70⅞ × 70⅞ in. (180 × 180 cm)

Colección Patricia Phelps de Cisneros, New York

FRASE SÓLIDA—HOMERO IMAGINÁRIO
(*STRONG WORDS—HOMER'S
IMAGINATION*), 2002

Illustrated book with stone and rubber-stamped
ink on wooden pedestal
15¾ × 13¾ × 1⁹⁄₁₆ in. (40 × 35 × 4 cm)

Private collection, Rio de Janeiro

EURECA (EUREKA), 2001

Polished stainless steel, mirror, and glass sheets
59 × 19⅝ × 23⅝ in. (150 × 50 × 60 cm)

Profili Collection

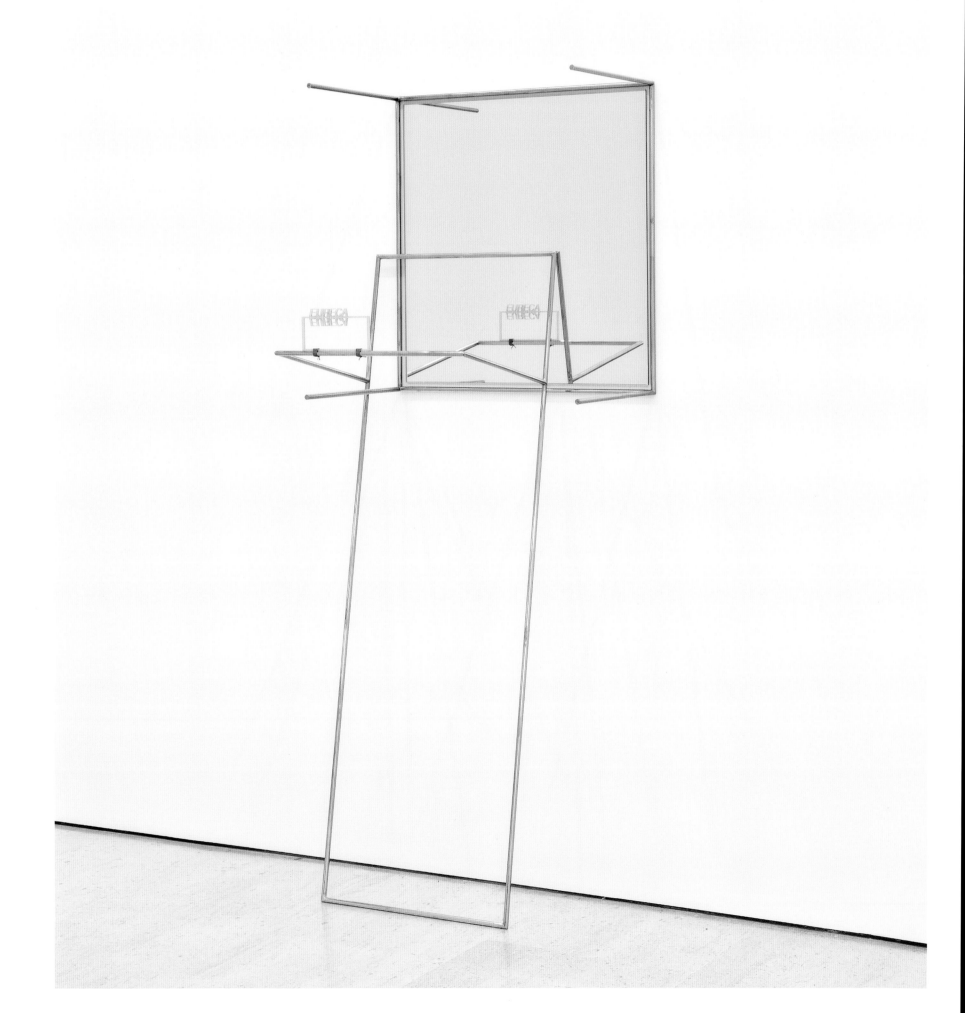

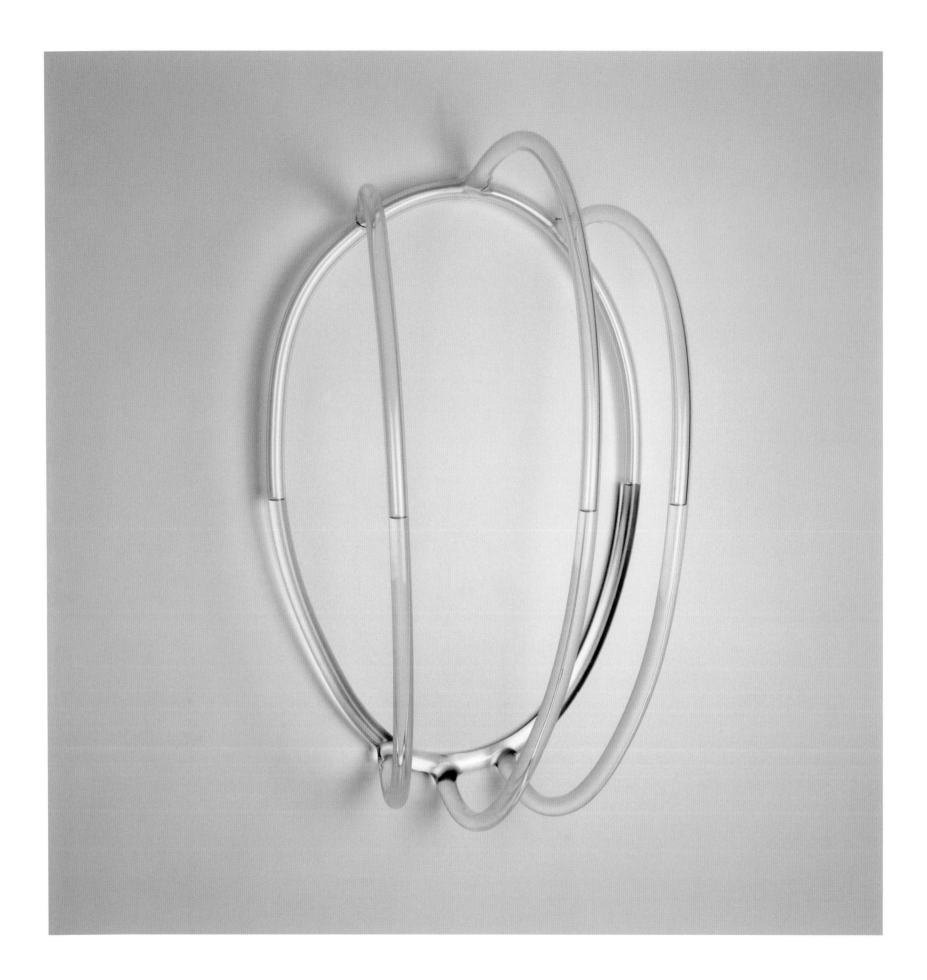

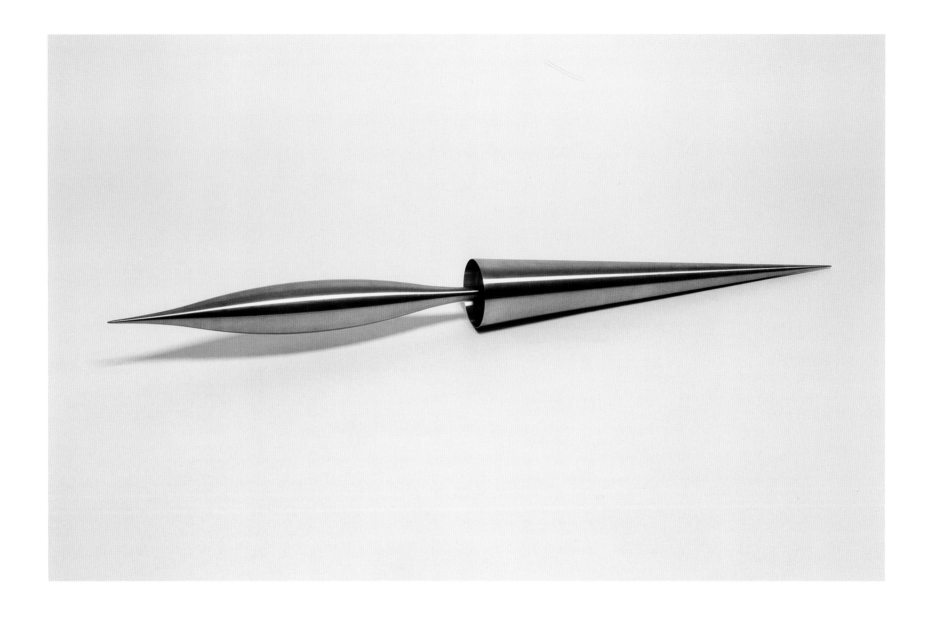

VIDRO, ÁLCOOL
(*GLASS, ALCOHOL*), 1994

Glass and alcohol
19¾ × 14⅛ × 6¹¹⁄₁₆ in. (50 × 36 × 17 cm)

Andrea and José Olympio Pereira, São Paulo

OBJETO DE AÇO
(*STEEL OBJECT*), 1978

Stainless steel
4¾ × 47¼ × 4¾ in. (12 × 120 × 12 cm)

Andrea and José Olympio Pereira, São Paulo

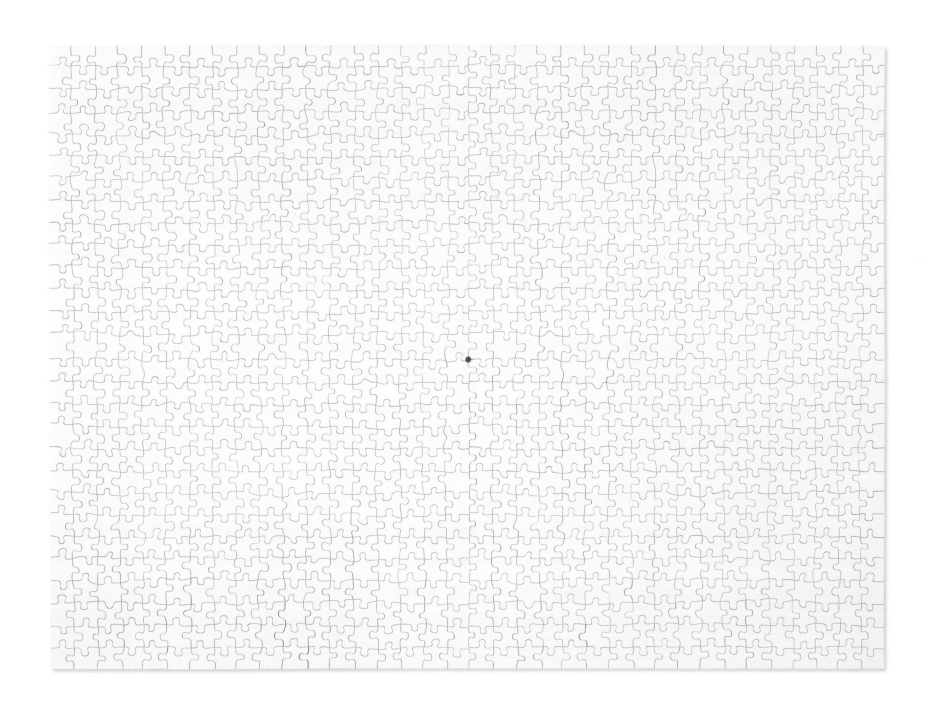

QUEBRA-CABEÇAS (PUZZLE), 1976

Enamel paint on cardboard
19¾ × 27½ in. (50 × 70 cm)

Private collection, Rio de Janeiro

DESENHO (DRAWING), 2000

Metal, acrylic paint, collage, and stamp on cardboard
28¾ × 19⅞ in. (73 × 50.5 cm)

Private collection, Rio de Janeiro

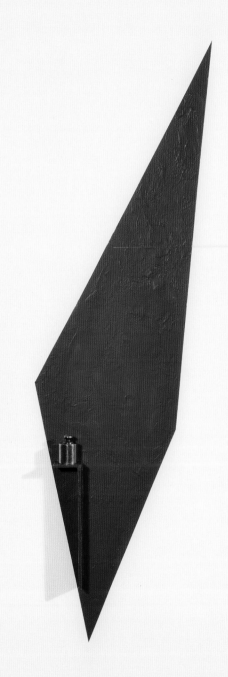

BRAQUE

CONDUTORES DE PERCEPÇÃO
(*PERCEPTION CONDUCTORS*), 1969

Glass and silver in velvet-lined box
2⅜ × 15¾ × 5⅞ in. (6 × 40 × 15 cm)

Private collection, Rio de Janeiro

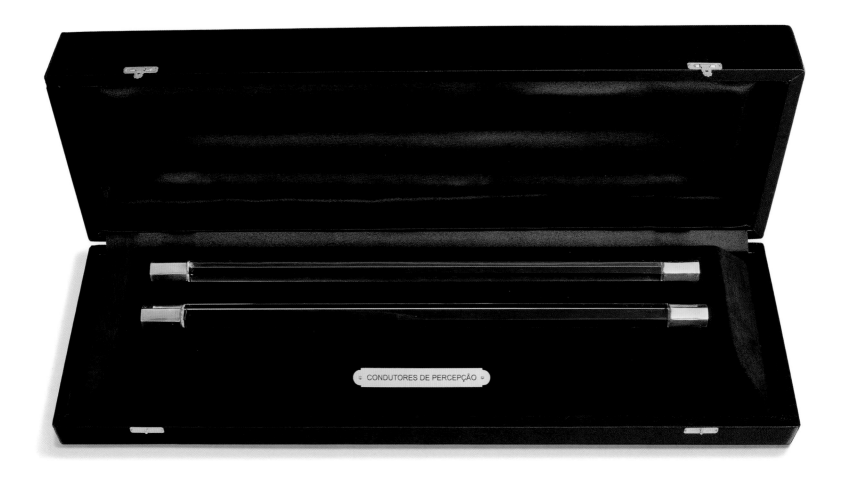

CONDUTORES DE PERCEPÇÃO

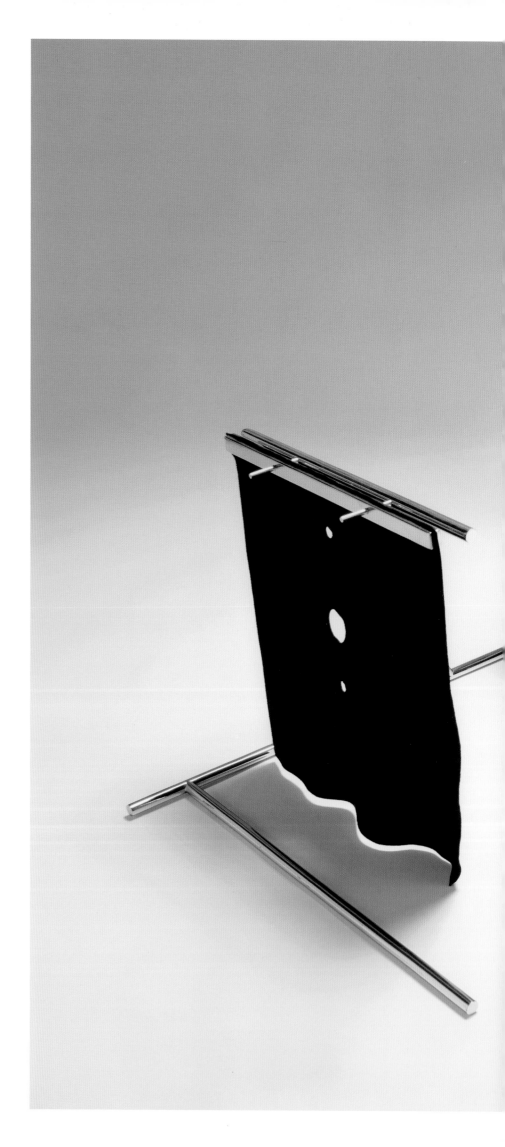

PLANISFÉRIO (*PLANISPHERE*), 2011

Stainless steel and suede
14 × 71¼ × 18¹¹⁄₁₆ in. (35.5 × 181 × 47.5 cm)

Private collection, Rio de Janeiro

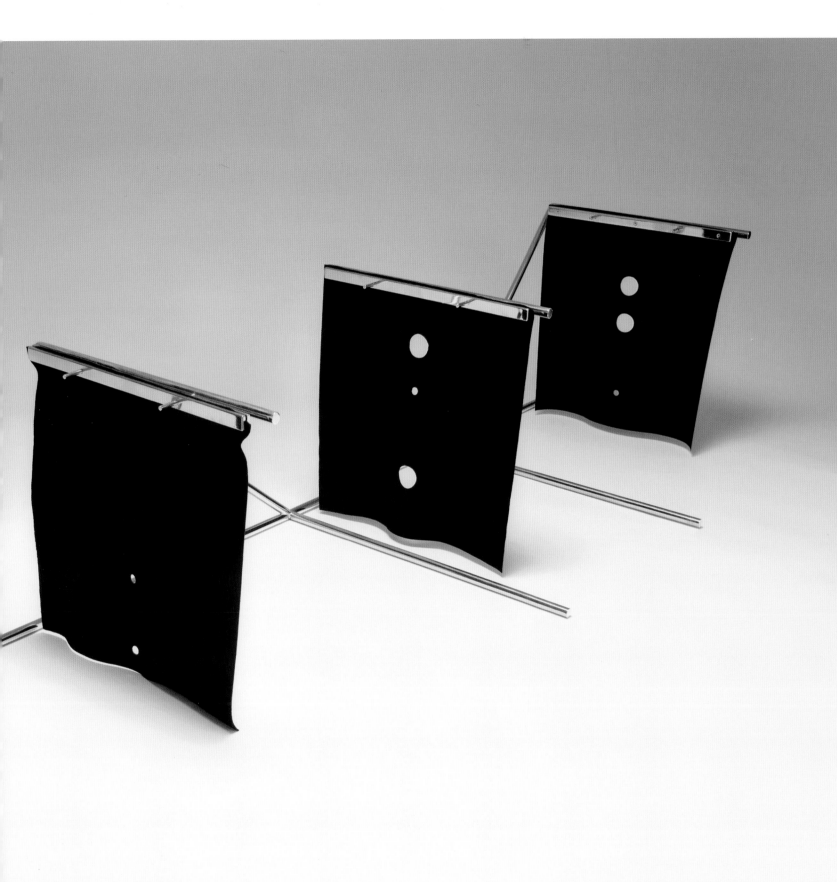

DESENHO (DRAWING), 2007

Ink, watercolor, metal, and collage on paper
31½ × 23⅝ × ¹³⁄₁₆ in. (80 × 60 × 2 cm)

Private collection, Rio de Janeiro

DESENHO (DRAWING), 2011

Ink, acrylic paint, metal, and collage on cardboard
28¾ × 40 × 1 in. (73 × 102 × 2.5 cm)

Celma Albuquerque, Belo Horizonte

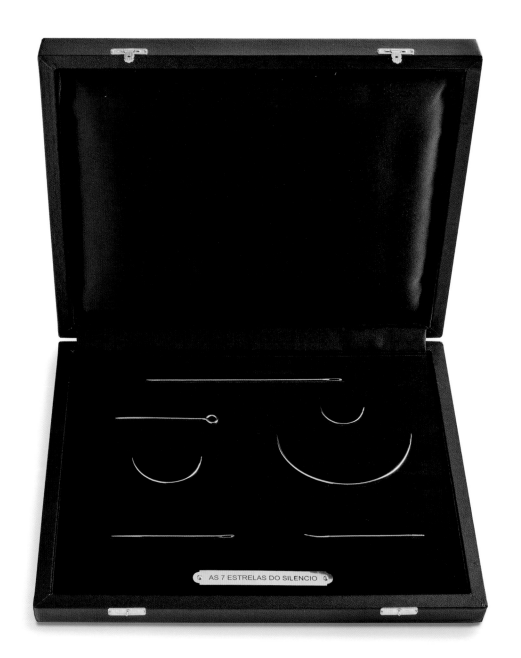

AS SETE ESTRELAS DO SILÊNCIO
(THE SEVEN STARS OF SILENCE), 1970

Silver needles in chromed steel box lined with velvet
1⅜ × 11¾ × 9⅞ in. (3.5 × 30 × 25 cm)

Gilberto Chateaubriand MAM RJ Collection

PLATÃO (PLATO), 1996

Polished stainless steel and chrome
11⅞ × 29⅛ × 4¾ in. (30 × 74 × 12 cm)

Patricia and Washington Olivetto, São Paulo

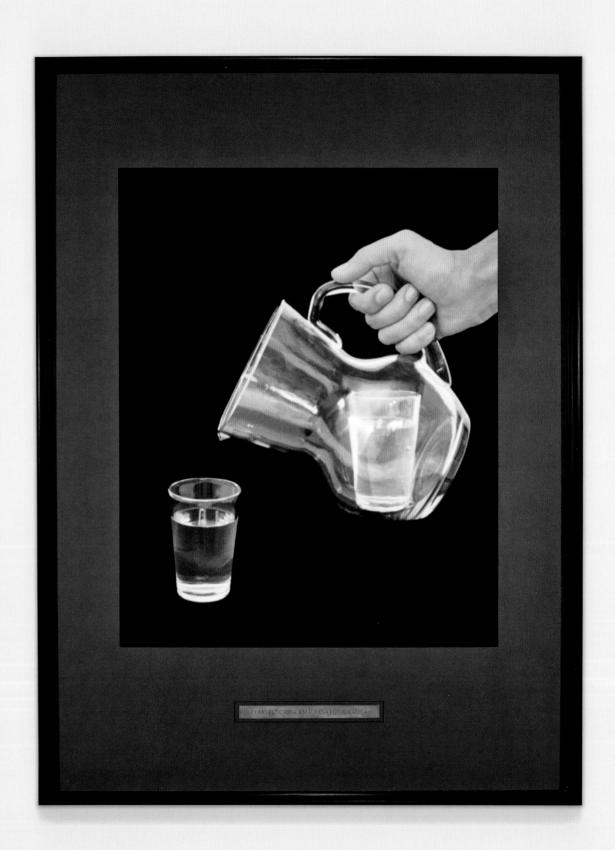

COMO FUNCIONA A MÁQUINA FOTOGRÁFICA

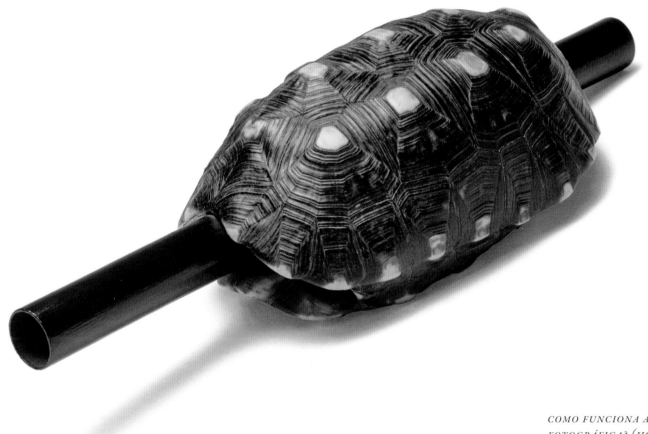

*COMO FUNCIONA A MÁQUINA
FOTOGRÁFICA? (HOW DOES
THE CAMERA WORK?)*, 1977

Silver gelatin print
37 ⅜ × 27 ¹⁵⁄₁₆ × 2 ⁹⁄₁₆ in. (95 × 71 × 6.5 cm)

Private collection, Rio de Janeiro

*CONVITE AO RACIOCÍNIO
(INVITATION TO REASONING)*, 1978

Painted iron and turtle shell
5 ⅞ × 17 ¾ × 7 ⅞ in. (15 × 45 × 20 cm)

Letícia Monte and Lula Buarque
de Hollanda Collection

CINEMA (CINEMA), 1981

Enamel on copper plate
5⅞ × 27⁹⁄₁₆ × 19¹¹⁄₁₆ in. (15 × 70 × 50 cm)

Private collection, Rio de Janeiro

*SÉRIE NEGRA NATUREZA MORTA
(THE BLACK SERIES, STILL LIFE)*, 2005

Black granite, stainless steel, glass, and yarn
70⅞ × 51⅛ × 137⅘ in. (180 × 130 × 350 cm)

Collection of Phoenix Art Museum,
museum purchase with funds provided by
Miriam and Yefim Sukhman in honor of the
museum's 50th anniversary

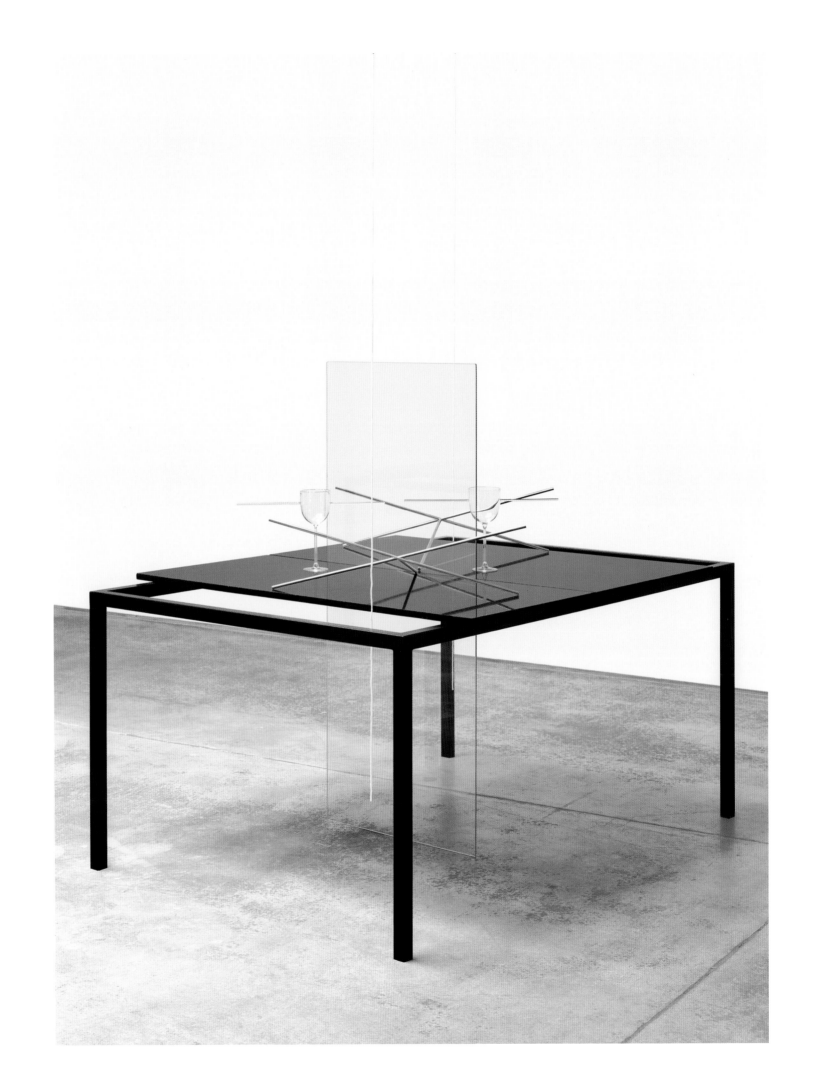

GARRAFAS COM ROLHA
(*BOTTLES WITH CORK*), 1975

Chinaware and corks
9⅞ × 7⅞ × 3½ in. (25 × 20 × 9 cm)

Liba and Rubem Knijnik Collection,
Porto Alegre

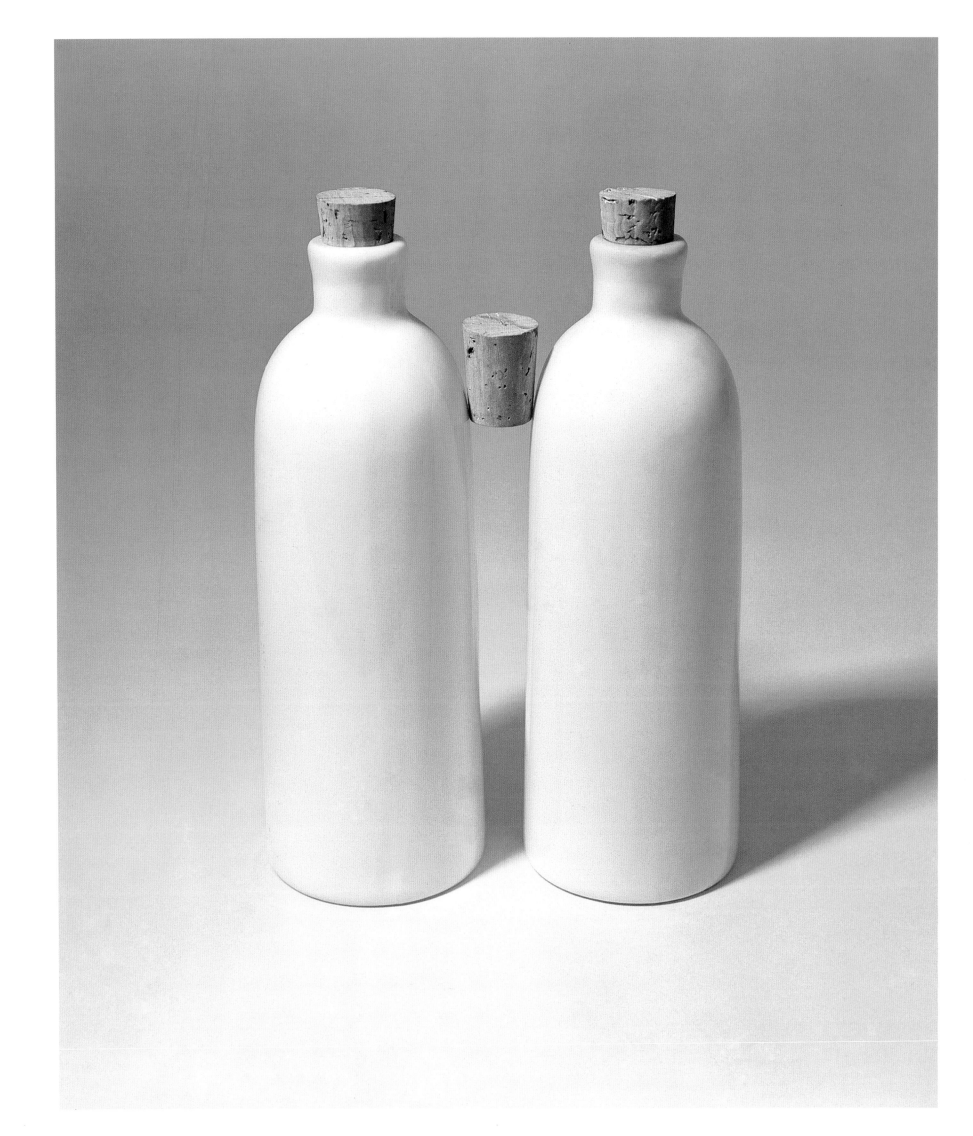

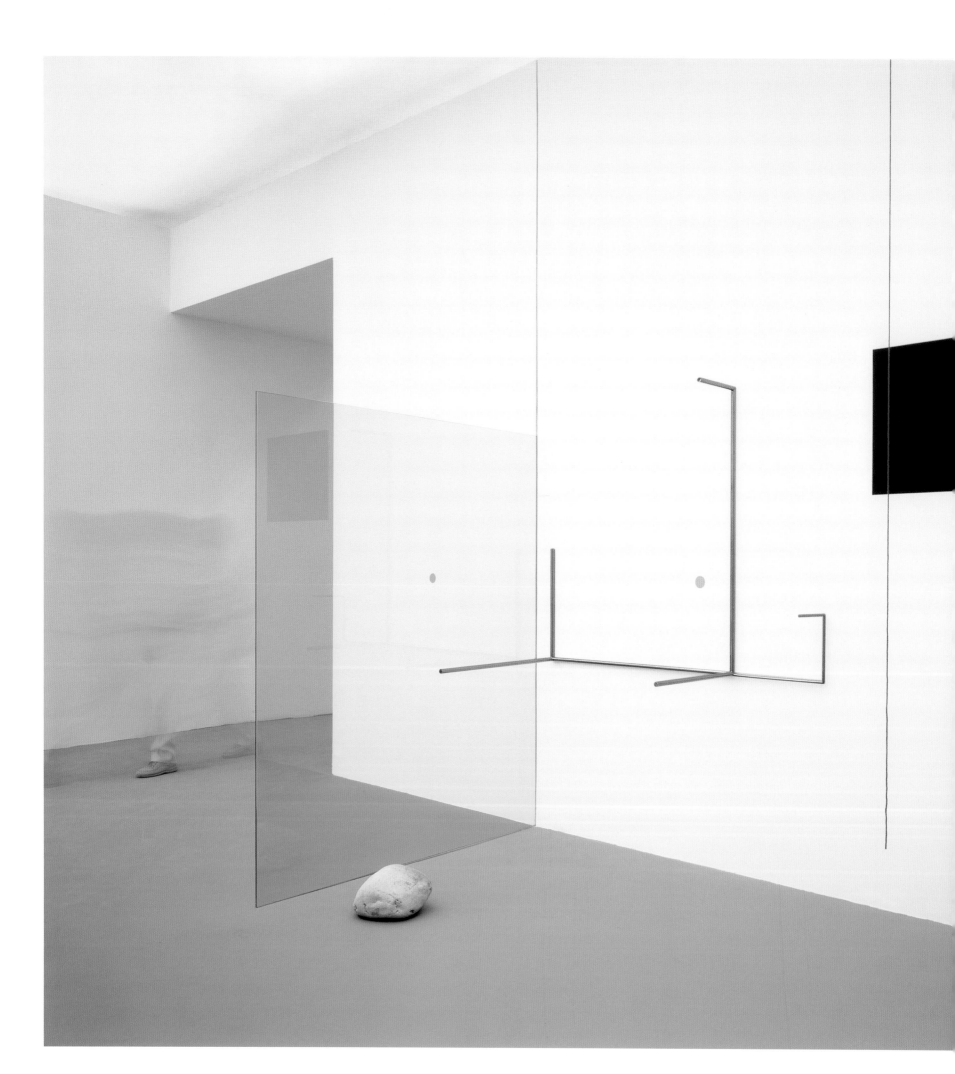

MEIO ESPELHO SUSTENIDO
(*HALF MIRROR SHARP*), 2007

Stainless steel, glass sheets, vinyl, yarn, and stones
114³⁄₁₆ × 275⁹⁄₁₆ × 70⁷⁄₈ in. (290 × 700 × 180 cm)

Private collection, Rio de Janeiro

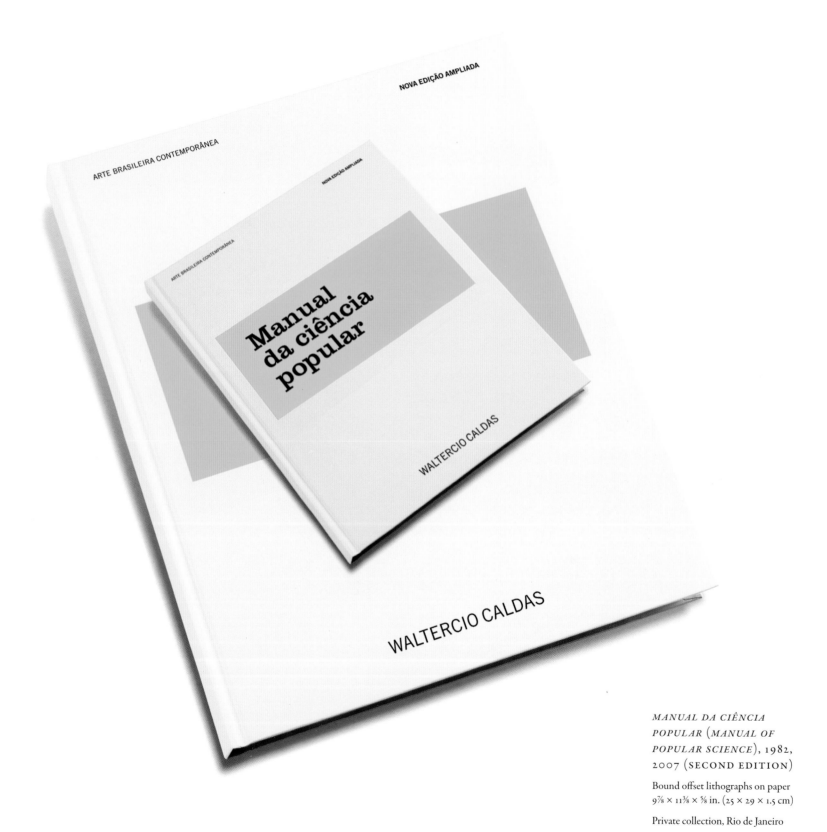

NOVA EDIÇÃO AMPLIADA

ARTE BRASILEIRA CONTEMPORÂNEA

NOVA EDIÇÃO AMPLIADA

ARTE BRASILEIRA CONTEMPORÂNEA

Manual
da ciência
popular

WALTERCIO CALDAS

WALTERCIO CALDAS

MANUAL DA CIÊNCIA
POPULAR (*MANUAL OF*
POPULAR SCIENCE), 1982,
2007 (SECOND EDITION)

Bound offset lithographs on paper
9⅞ × 11⅜ × ⅝ in. (25 × 29 × 1.5 cm)

Private collection, Rio de Janeiro

The
QUESTION

———

Richard Shiff

I MAKE NO PRETENSE to explain Waltercio Caldas or his art. In response to his actions, I venture no more than interpretation, always less than explanation. My analysis is likely to remain naïve, founded throughout on feeling and free association. References to the artist's history, context, and culture—the assurances of intellectual authority—will be lacking.

To observe from a position of little information may be appropriate in Caldas's case. His art remains so close to the raw operation of thought—to thought in its intuitive incipience—that the line between coherence and incoherence blurs. Attempts at explanation founder when all aspects of thought, logical or not, share in potential validity. Given the character of Caldas's practice, a contextual explanation by way of partisan issues or intellectual and aesthetic fashion would seem tenuous and unrevealing. He is a formalist of thinking, a thought-formalist, whose objects defy summary description, even when reproduced in a book where the artist himself provides preliminary verbal glosses. Caldas has at least one feature in common with those who share a visual orientation: he forms challenging thoughts not only from abstract words and concepts but all the more inventively from physical matter: stone, metal, glass, plastic, paper, fibers, water, air, light.

Critical naïveté has the advantage of relating to the spirit of Caldas's popular science, his art of everyday chance, his array of compelling intuitions. He treats thinking as if it were feeling—immediate and free—the kind of thinking that the thinker may not fully understand while performing its operations. In turn, I seek only to think Caldas's thought, to feel the thought as it forms. Beyond spells of mental and sensory confusion, the risk in concentrating the senses and mind with such intensity is apophenia: discovering a pattern—a secret knowledge, a source of privilege and power—where none exists. Caldas's art resists such order. In deference to it, my commentary will not seek a pattern. If one is hidden, it should remain so.

Prerational naïveté bypasses stages of reasoning just as postrational prejudice does. Prejudice has its own naïveté, but of an inverted type. Prejudice involves assuming a level of knowledge and understanding—whether open and public or concealed and privileged—that no one fully possesses. Given the prejudice that cultural indoctrination instills, we should invert the inversion: prejudice (assumed knowledge, ideology) is not the curative antithesis of rampant naïveté; rather, naïveté is the curative antithesis of rampant prejudice and its cultural clichés. Caldas may be motivated by the

realization that we know less than we believe we do. Commenting on the situation, the art historian Paulo Venancio Filho reached an apt conclusion three decades ago: "Exposing oneself to the disquiet of knowing nothing . . . is the contemporary experience of art."[1] Caldas induces us to reflect on our contemporary quandary, our disquiet. He sides with naïveté against prejudice. Much of what we believe we know, we do not. And even if we did know, we would do better to forget—or to question.

NIETZSCHE

I have been interpreting from the start. To refer to what Caldas produces—objects, situations, thoughts—as works of art amounts to interpretation twice over. "Caldas or his art," I wrote in my initial sentence, without hesitation. The statement implies, first, that Caldas is the conscious producer or creator of the things to which we assign his name; the association of the person and the thing is not merely the result of chance, as so often happens. If a man raises his arm and lightning strikes, he should not be regarded as the producer of the lightning; yet mistakes of this kind are hard to avoid not only for observers but also for the arm raiser—those who jointly witness the coincidence. Second, the statement assumes that whatever Caldas produces is likely to count as an instance of art. With respect to determining the second matter, well, I have met Caldas. He leaves me with the impression of being an artist because his talk flows with ironies that, to me, seem very artistic. Art can hinge on an individual's judgment. If Caldas is the artist I think he is, then he ought to be producing art. And he is hardly alone. Art is never complete, he asserts: despite our advanced science, art "still continues to be made"; and many make it. When art takes a romantic turn, it produces instances of rational inversion or, as Caldas writes, "didactic disorientation."[2] Can such art be popular (accessible, self-revealing) and still challenge our common knowledge, our popular science?

One way to approach a work by Caldas is through the question to which it provides an answer. Art answers a need. A question might be: what is the beautiful? In response, a work of art would demonstrate beauty. Or it might merely present the initial question, leaving the answer to observation of existing custom. Much of our contemporary art is archival. It gathers cultural objects and displays them to provoke sustained analysis or to induce ironic self-consciousness regarding the commonplaces we accept. We live in the midst of beauty, produced around us by popular practice. We need only assemble its examples and inspect them.

Selecting from the archive, contemporary art often opposes one cultural product to another, playing a semiotic game of differential value. Round face, oval face: which type counts as beautiful and to whom? Ever since the 1960s, when Marcel Duchamp became the preeminent reference for critics, new examples of art have been praised for questioning not only officially established institutional values but also the popular—our prevailing concepts of, or attitudes toward, just about anything regarded as normative. Every standard receives its challenge, whether a canon of beauty, a definition of art and its originality, an element in the construction of a social order, a principle of economic exchange, or a factor in the play of gender identity. Every cultural practice is subject to critique, and nothing remains sacred (as the cliché says). The role of the artist has been that of the philosopher-fool in a medieval European court: to question the truths that everyone assumes. Virtually by definition, anything so generally accepted as to qualify as "common sense" has, as Roland Barthes once put it, "every chance of being mythical."[3] Universal credence within a social body perpetuates its mythologies. Reality—the reality of sensing and thinking—belongs exclusively to the individual. Each of us has a piece of reality, but not the same piece.

Caldas questions fundamental principles, the greatest generalities. Trivialities and nullities do not concern

him. In this respect, he resembles Duchamp. But when I consider the tension between mythologies and realities, I wonder whether Caldas is more the heir to Friedrich Nietzsche than to Duchamp. Both Nietzsche and Caldas authored studies of "science" that are neither actual science nor scientific (nor even scientistic) in their method. Nietzsche's *The Gay Science* (1882, 1887) and Caldas's *Manual of Popular Science* (1982, 2007) are treatises that constitute poetry; at a century's remove from each other, their common subject is poetic art broadly conceived—acts of willful human creativity. The type of "popular science" that becomes Caldas's target of investigation is knowledge on an intuitive level—signs of human mentality operating outside the parochial boundaries of cultural divisiveness. Caldas moves beyond "common sense" toward not-so-common realities.

It would violate the spirit of Nietzsche or Caldas to impose strict analytical terms on their poetic craft. Yet to a certain extent, commentary must be analytical and logically ordered if it is to illuminate its object; poetic license is not the best reflection on poetic license. I can use Nietzsche to set a grounded philosophical tone for my interpretation of Caldas without claiming any historical connection other than the coincidental confluence of these two sources of imaginative thought.

Nietzsche asks the kind of question that intrigues a person like Caldas: "How did logic come into existence in man's head?"[4] Inverting the central term, he answers: "Certainly out of illogic, whose realm originally must have been immense." Reading Nietzsche induces me to join in playing his game of questions, replaying his commentary on logic. Things that make sense are fewer than things that do not. This is a fact, Nietzsche seems to say; this is reality. But conventional patterns of thought, organized to slight the nonsensical or force it into ill-fitting molds, ignore reality. With our prejudicial logic, our common sense, we give the impression of maintaining intellectual control over anomalous situations. Nietzsche continues: "Innumerable beings who made

inferences in a way different from ours perished; for all that, their ways might have been truer." Survival does not necessarily entail possession of the truth. The only beings to remain on the evolutionary ladder are those that reason as we do—true or false, real or mythological, we cannot determine. "Those, for example, who did not know how to find often enough what is 'equal' as regards both nourishment and hostile animals—those, in other words, who subsumed things too slowly and cautiously—were favored with a lesser probability of survival than those who guessed immediately upon encountering similar instances that they must be equal."

Imagine that you observe the tiger attacking your neighbor. It would be prudent to assume that the next tigerlike creature may well be stalking you, and more prudent still to either run or spear it than to stand in place to test the hypothesis. Logic establishes its lesson: a person should generalize from experience. Yet logic is arbitrary; it has no ultimate ground. "The dominant tendency," Nietzsche writes, "to treat as equal what is merely similar—an illogical tendency, for nothing is really equal—is what first created any basis for logic." To the question "What is equal?" our inherited logic replies that similar things are equal enough.[5] So we generalize, concluding that all tigerlike creatures ought to be classed as tigers. All must be predatory: keep your distance. And yet this risk of being attacked is itself an abstraction, an assumed reality ever in need of confirmation through the next example. Logical inference is prejudicial: an anomalous, friendly tiger will be speared along with the menacing ones. We can calculate the characteristic moves of tigers and estimate our chances. Survival of the individual becomes statistical. Logic breeds more logic.

The tiger is my example, not Nietzsche's. He might invoke deities as examples, or the laws of science. Religion and science: both are abstract structures of popular belief. As if to expose these two pillars of knowledge for the mythologies they are, Nietzsche extended his countercultural exercise, separating description from

explanation. "'Explanation' is what we call it," he asserts, "but it is 'description' that distinguishes us from older stages of knowledge and science. Our descriptions are better—we do not explain any more than our predecessors. We have uncovered a manifold one-after-another [effects following from causes] where the naïve man and inquirer of older cultures saw only two separate things." As always (it seems), generalization and abstract categories provide the necessary logical structures: "We operate only with things that do not exist: lines, planes, bodies, atoms, divisible time spans, divisible spaces." Each is an abstraction, defined by a unit of measure.

If Caldas—just like Nietzsche, but active a full century later—questions the application of customary abstractions to specific cases, what are the questions he is asking? Or rather, what questions do his objects, his specific cases, raise by their existence? For one thing, they undermine the status of "things that do not exist" (units of measure, elements of logic), making such things less relevant, or even irrelevant, to the experience of actual objects and events. If Caldas's questions cause us to reflect on what exists and what is mere figment, then his art finds a purpose. The answers would constitute pragmatic knowledge. Like Nietzsche, Caldas will be redeemed for posterity by the efficacy of his philosophical insight.

CALDAS

The *Manual of Popular Science* presents thirty-three cases of—what to call them?—"constructed casualties." This phrase links two terms from Caldas's foreword to the expanded edition of 2007.[6] I propose to review a few of the instructive cases from the *Manual*. Each demonstrates a principle of popular science, an instance of intuitive understanding. As with other experiences of intuition, a person may well become frustrated if asked to prove the validity of any particular instance. I can only guess at the question to which each object or situation responds. My guess, my hypothesis, interprets Caldas's art by furthering, but hardly resolving or justifying, its unconventional logic.

Caldas raises an issue that amounts to a warning: "Will these objects one day have enough autonomy to question their printed versions?"[7] The autonomous objects, when set loose in the physical world, are seen and inspected more completely than their printed representations, their projected effigies. The photographic images on the page spreads of Caldas's *Manual* are mere low-resolution blurs in relation to the phenomenological plenitude of the actual objects within a specific spatial environment. Although some of Caldas's popular-science examples may lack a real-world analogue—#29, *How Does the Camera Work?* (see page 76) seems to depend on double exposure—most suggest a potential for movement or transformation that a physical model, as opposed to a projected camera model, would better manifest. In this respect, consider #23, *Dice on Ice* (see page 47), which evokes a process of melting that would eventually expose the enclosed die to full sensory scrutiny. Regarding the photograph, Caldas notes: "Useless to look any longer, as this image will always be the same as it was at the precise moment it was first seen." And yet from at least one perspective, the statement is patently false, because a viewer's perception of this same image—or any image—must alter its emotional charge over time. If we watch for change as a material meltdown, we will not discover it; but our attitude will alter and evolve, and *this* change we can feel. Even moments of perspicacity and stability generate doubt.

The graphic strategy of the *Manual* participates in determining the questions that would presumably unlock each of Caldas's projected images. His mode of photographic display mimics those used in books of instruction by eliminating extraneous elements from view; in most instances, the page spreads present their objects against neutral grounds, with no indication of a floor, wall, or horizon. The source and direction of

illumination are also sometimes suppressed. The effect is to conceptualize the objects, to lift them from an environment of contingency, to present them as generic types—the stuff of theory. A theory of what? Perhaps of logic—-the fantasy of logic. Perhaps a theory of reality.

My questions may not be Caldas's questions. His demonstrations of popular science imply a theory without being explicit about it. It might be a theory of chance, accommodating situations too specific to fall within the scope of a general statement. Such a proposition would be tantamount to a theory of reality, for reality consists of statistical chances, *specifics*, as opposed to the generalities that form a mythology. Any specific thing that exists has beaten the odds, since more things fail to exist than succeed. Just by existing, any material thing is unique. Conceptual abstractions (such as uniqueness itself) disguise this circumstance. Caldas recalls that the gods of the ancient world exhausted themselves in their "compulsive creation of chance occurrences."[8] Every creation of the gods gave the appearance of a chance event because every object or condition the gods produced was utterly without precedent, unforeseen in relation to anything existing. To be creative, the gods could not repeat one another or themselves. They could not generalize. Each of Caldas's specific cases is like a god's creation. Each nevertheless seems to suggest a general question, or many general questions. "Your doubts will never be explained," Caldas says, perhaps including himself among the readers of his text, admitting that he is mystified by it, like a god surprised at the results of his own most recent creative effort: "The author would like us to feel as if we were on a bottomless book."[9] Caldas's *Manual* reaches no resolution, no foundation. To follow its instruction is to learn without end, yet to realize how much one never knows.

Although the *Manual of Popular Science*, like popular science itself, is an object of mass consumption, my questions and suspicions, the effects of Caldas's images, are effects on me alone. The presentation of the *Manual*

becomes a cause of my sensing, feeling, and thinking: my reality. Should I regard the material examples or the abstract questions as primary? A definitive choice would impose an ideological classification on Caldas's art and restrict the philosophical inquiry. Such a qualification would limit the effect and be of no benefit to the interpreter.

Nevertheless, the format of a book implies a direction to its reasoning. When one of Caldas's individual cases occupies both pages of its two-page spread, it evokes a situation of "before" and "after"—we read or scan a book from left to right. Consider case #1, *The Image Is Blind*. Caldas's textual gloss states: "Clear merthiolate applied with a hypodermic syringe into a ping-pong ball." The three items (a boxed supply of Merthiolate, syringe, Ping-Pong ball) are pictured together on the left of the spread, with the punctured ball on the right. As a corresponding question, I would venture: "What is appearance?" Appearance can be revealed or hidden, transparent or opaque. The antiseptic known by the trade name Merthiolate is often dyed, but this variant is uncolored or clear—in Portuguese, *incolor*—as its packaging indicates. "*Incolor*" connotes an indeterminate state, indecision—like not knowing whether to turn orange or purple. A transparent liquid can reveal any color and can bear any color (hold any dye). Whether it is transparent or opaque, we nevertheless remain blind to the liquid injected within the ball. It can have any appearance or make no appearance. I suspect that further thought along these Caldasian lines would encounter all known senses of "appearance" as well as many as yet unknown. At an analogous stage, C. S. Peirce suspended his own discussion of the judgment of appearance: "The examination of this point would be lengthy [involving] complications few would have the patience to follow."[10]

Caldas, however, has the advantage of poetic visual imagery. His class of "blind" appearances ("the image is blind") seems extended by case #9, *Carbon Paper between Mirrors*. Here, metal clasps ensure that two

#1, THE IMAGE IS BLIND,
from *Manual da ciência popular
(Manual of Popular Science).*
Text by Paulo Venancio Filho.

Rio de Janeiro: Ediçao Funarte, 1982.

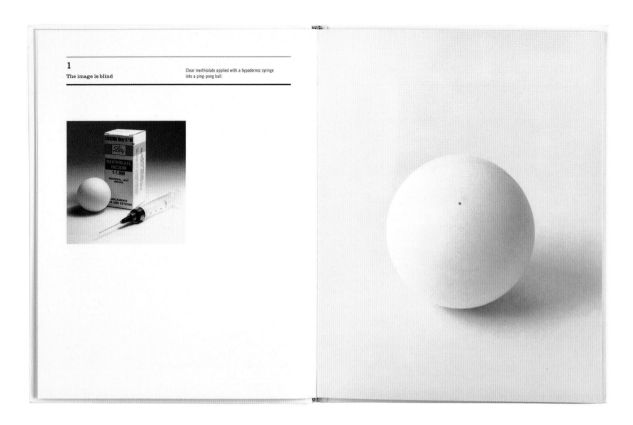

1

The image is blind

Clear merthiolate applied with a hypodermic syringe
into a ping-pong ball.

mirrors make physical contact with a sheet of carbon paper pressed between them. The opaque sheet largely prevents the mirrors from reflecting each other; but, presumably, the paper records a mirrored imprint, at least on its carbon-coated side. What is a mirrored imprint? Perhaps this concept signifies nothing if the mirror has nothing to reflect. Is it reflecting the carbon paper, which carbons the reflection in turn? We have no means of seeing such a putative action in order to verify it. Whatever appears (blindly) in the mirror and on the surface of the carbon must be an index of the opposing surface that establishes the contact. I imagine an endless transfer of unseen images. The question might be: "What is an index?" Or: "What is an indexical sign when no sentient being can perceive it except by a second index (Caldas's photograph), which presents it to thought?" This object generates a phantom index: materially bound, yet lacking a material presence, and with only a symbolic allusion to its concept.

Case #11, *Perpetuum Mobile* (perpetual motor or motion machine), evokes an irretrievable loss of energy in the performance of an action. Yet if the pile of dice pictured on the left of the two-page spread is the source of the chair-like construction of dice shown at the right, an increase in the number of cubic elements has occurred. It seems that the two photographs do not represent dice in the same way: one depicts dice as substance, the other as structure. Like a symbolic index and a material index, substance and structure fail to equate to each other: substance is indeterminate; structure is determined. Nietzsche wrote: "In order that the concept of substance could originate—which is indispensable for logic although in the strictest sense nothing real corresponds to it—it was likewise necessary that for a long time one did not see nor perceive the changes in things."[11] For dice to amount to substance, each die must be perceived as the equal of any other. I think that the relevant question of *Perpetuum Mobile* is not "What is structure?" but "What is substance?" This is the hard question, challenging us to determine the indeterminate.

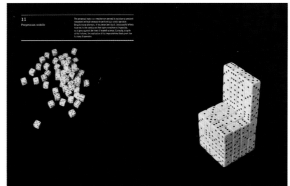

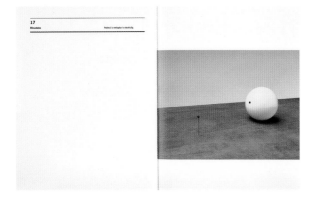

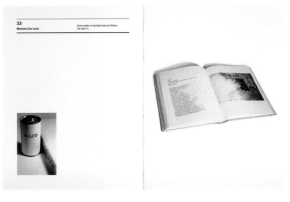

#9, CARBON PAPER
BETWEEN MIRRORS,
from *Manual of Popular Science.*

#11, PERPETUUM MOBILE,
from *Manual of Popular Science.*

#17, EINSTEIN,
from *Manual of Popular Science.*

#33, MATISSE, TALCUM,
from *Manual of Popular Science.*

Caldas glosses case #17, *Einstein*, this way: "Instinct is metaphor in electricity." His sentence refers to metaphor but also embodies the form of metaphor (*x* is *y*). Its three terms—"instinct," "metaphor," and "electricity"— are abstractions of different sorts. One refers to a sensory and mental operation (organic); one refers to a linguistic operation (symbolic); one refers to a physical phenomenon (inorganic). The dark, round, ball-like head of a pin faces a dark circular spot on a Ping-Pong ball, as if the spot were a projection of the pinhead at a distance. Because the source and its projection are visible within a single photographic, light-sensitive moment, the transmission of the spot that indicates both must be extremely fast, meeting no environmental resistance. In fact, from pin to Ping-Pong ball the move must occur at the speed of "metaphor in electricity" (in a vacuum, electricity moves at the speed of light). Caldas's *Einstein* seems to ask a physicist's question, part of the lore of popular science: "What is the speed of light?" Here, a useful answer would be philosophical rather than numerical, for speeds as fast as that of light have little experiential meaning (half the speed of light is still fast). Instead, we wonder to what other kinds of projection we should compare light projection. Does instinct—mental projection—move as fast as light and electricity? Why do we associate thought with flashes of light and electrical sparking?

The question raised by case #33, *Matisse, Talcum*, is as fundamentally abstract as light is fundamentally material: "What is identity?" On the left side ("before") is a tin of powder by TALCO, set beside a book about art by MATISSE. On the right side ("after") are specific material manifestations of these two general identities: some powder spread across a text that verbally describes, and a photograph that visually illustrates, one of Henri Matisse's paintings. How far removed from the reality of Matisse (even in reproduction) is his name? Why should I assume that the talc on the pages of the Matisse book is a sample of the substance known as Talco? Other questions follow: "What is context?" "What is reference?" "What is a sign?"

2

Spare art object

The photos show the object conceived especially for this purpose.
By the way: all objects are spare objects.

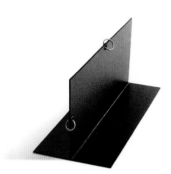

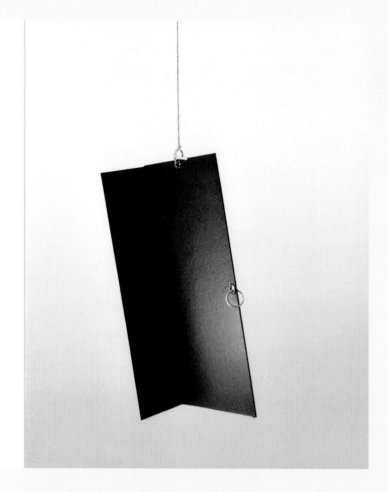

3

Ordinary plate with rubber bands

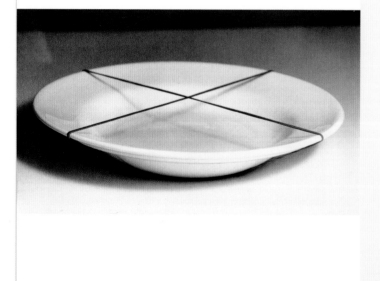

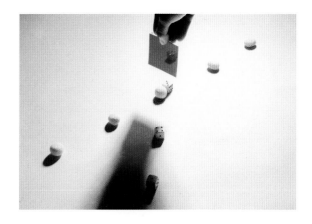

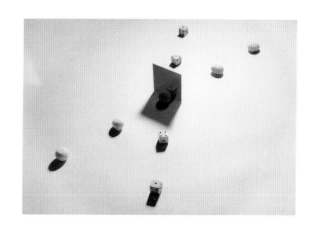

We don't need to believe in everything we see, do we?
There is a doubt that belongs to clarity.

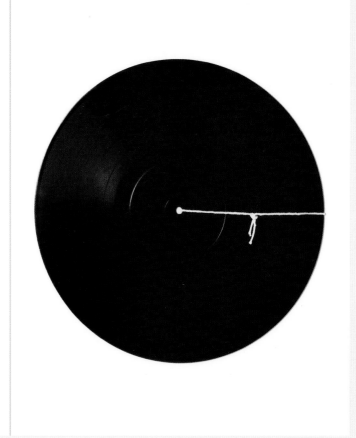

LITHOGRAPH FROM
*O LIVRO VELÁZQUEZ (THE
VELÁZQUEZ BOOK)*, 1996

Bound offset lithographs on
paper, edition 1,096/1,500
10⅝ × 12¼ in. (27 × 31 cm)

Blanton Museum of Art, Archer M.
Huntington Museum Fund, 2003

LITHOGRAPH FROM
*O LIVRO VELÁZQUEZ (THE
VELÁZQUEZ BOOK)*, 1996

Bound offset lithographs on paper,
edition 1,096/1,500
10⅝ × 12¼ in. (27 × 31 cm)

Blanton Museum of Art, Archer M.
Huntington Museum Fund, 2003

VELÁZQUEZ

When does a book, *Velázquez*, count as a book focused on Velázquez? In 1996, Caldas published a book-like object that cannot be read, or even consulted, in the customary literary way.[12] Its unnumbered pages have a layout that gives the vague appearance of a study of the painter Diego Velázquez. The surname, blurred, is discernible as a title on the front cover. On the back cover, equally blurred, is the name "Waltercio Caldas," identifying this artist as author—or as designer, because we cannot determine whether a written text, perhaps corrupted in the printing process, belongs to this book or merely to its visual look, as if the space of a prototype were being graphically occupied for a text yet to come. On the individual pages, the effect of pervasive blur is all the more severe because the words are neither as isolated nor as large as on the two covers. With the exception of the section headings, the lines of type run on without spaces between would-be words. Each soft-edged line of text appears as a single gray bar.

Not every effect of visual blur is diminishing or detrimental. Blur that fails to resolve will focus sensory attention elsewhere. Because Caldas's account of Velázquez cannot be read, verbal codes cease to deflect an appreciation of the material features of the book—its size, heft, quality of paper, and structural design. Caldas's *Velázquez* is a project not only to be pondered but also to be held and touched, like a handheld sculpture.

Velázquez had a relatively fluid, somewhat blurred manner of brushwork; his contours waver, animating the image. Along with the lines of text, the pictorial illustrations of Caldas's book grossly exaggerate Velázquez's inherent blur, as if the pages were seen through a gauzy filter or a defocusing lens. Even more provocatively, the illustrations eliminate the human figure, the overt human presence essential to any conventional "reading" of Velázquez's meaning. The lack of human form introduces thematic blur, a reduction in apparent thematic content.

Do reliable traces of Velázquez remain, with his art still in force? Or does any book about an artist—with or without blur in its production—obscure its nominal topic (here, Velázquez) by imposing the will of its creative author (here, Caldas)? In lieu of Velázquez's *Prince Baltasar Carlos on Horseback*, Caldas's digitally manipulated illustration pictures the horse without the prince. And for the multifigured scene of *Prince Baltasar Carlos with the Count-Duke of Olivares at the Royal Mews*, Caldas's illustration eliminates both prince and horse, as well as all other figures, including those standing on a balcony, which in their absence becomes a dark architectural orifice. A certain play of light remains, but not the figures that would modulate it. We are left with a soft-focus rendering of a building, accompanied by faded gray bars of phantom description on the facing page.

These observations lead to a general question: "What is (a book of) art history?" We can only guess, case by case, how much of the trace of an artist (Velázquez) is needed to qualify a book as art history. The amount is inversely proportional to the assertiveness of the author (Caldas), who may become the artist of record, free to claim the book as either art or art history or both. It hardly matters that Caldas was known as an artist before he produced *Velázquez*, his book with the appearance of "art history." Books are made things, poetic exercises, whether the product of a writer, a photographer, or a sculptor. The more ordinary books are minor poems—cases of popular science—as are ordinary works of art. Like extraordinary things, even ordinary things are specific enough to be worth questioning.

Here is the question, finally: what is a work of art? It is whatever the gods make (materials, language), whatever artists make (images, texts, blurs), whatever we make (questions). Most theorists would be partial to only one, or possibly two, of these three groups of creators. But Caldas, like Nietzsche, would question, and potentially accept, all.

NOTES

1. Paulo Venancio Filho, "Preparatory Reading" (1981), in Waltercio Caldas, *Manual of Popular Science*, trans. Juliet Attwater (São Paulo: Cosac Naify, 2007 [1982]), 78. I thank Waltercio Caldas for his good humor and generosity. I am grateful also to Gabriel Pérez-Barreiro, Ursula Davila-Villa, Francesca Consagra, and Jason A. Goldstein for essential aid in completing this project.

2. Caldas, foreword to the first edition (1982), *Manual of Popular Science*, 5 (emphasis eliminated).

3. Roland Barthes, "The Photographic Message" (1961), in *Image—Music—Text*, trans. Stephen Heath (New York: Hill and Wang, 1977), 19.

4. For this and the following quotations from Nietzsche, see Friedrich Nietzsche, *The Gay Science*, trans. Walter Kaufmann (New York: Vintage, 1974 [1882]), 171–172.

5. Compare another writer of Nietzsche's era: "The principle that the mind can mean the Same is true of its [cultural] meanings, but not necessarily of aught besides"; William James, *The Principles of Psychology* (Cambridge, Mass.: Harvard Univ. Press, 1983 [1890]), 435 (emphasis eliminated).

6. Caldas, foreword to the new edition (2007), *Manual of Popular Science*, 4.

7. Ibid.

8. Ibid.

9. Caldas, foreword to the first edition, *Manual of Popular Science*, 5.

10. Charles Sanders Peirce, "Telepathy and Perception" (1903), in *Collected Papers*, ed. Charles Hartshorne, Paul Weiss, and Arthur W. Burks, 8 vols. (Cambridge, Mass.: Harvard Univ. Press, 1958–1960), 7:376.

11. Nietzsche, *The Gay Science*, 171.

12. Waltercio Caldas, *Velázquez* (São Paulo: Anônima, 1996).

O RECÉM-NASCIDO
(*THE NEWBORN*), 1976

Acrylic on wood
47¼ in. (120 cm) dia.

Collection Raquel Arnaud

O LIVRO CARBONO
(*THE CARBON BOOK*), 1980

Bound blotting and carbon paper
17 × 11⅞ × ¼ in. (43.2 × 30.2 × 0.7 cm)

Private collection, Rio de Janeiro

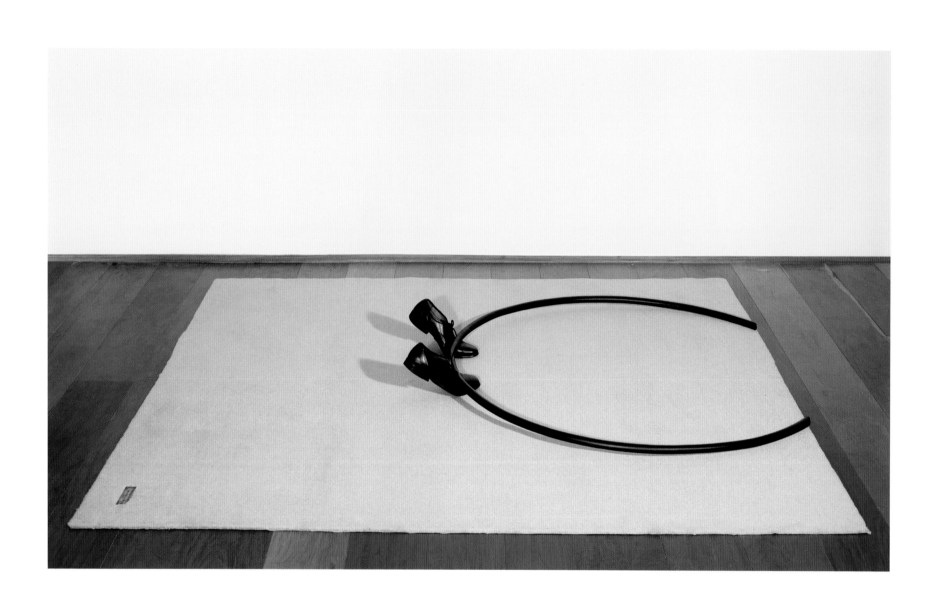

A EMOÇÃO ESTÉTICA
(AESTHETIC EMOTION), 1977

Painted iron and shoes on carpet
7⅞ × 80¹¹⁄₁₆ × 76¾ in. (20 × 205 × 195 cm)

Private collection, Rio de Janeiro

ÁGUA/CÁLICE/ESPELHOS
(WATER/GLASS/MIRRORS), 1975

Metal, mirror, glass, and water
16⅞ × 19⅞ × 5¹³⁄₁₆ in. (42.8 × 50.5 × 14.8 cm)

Private collection, Rio de Janeiro

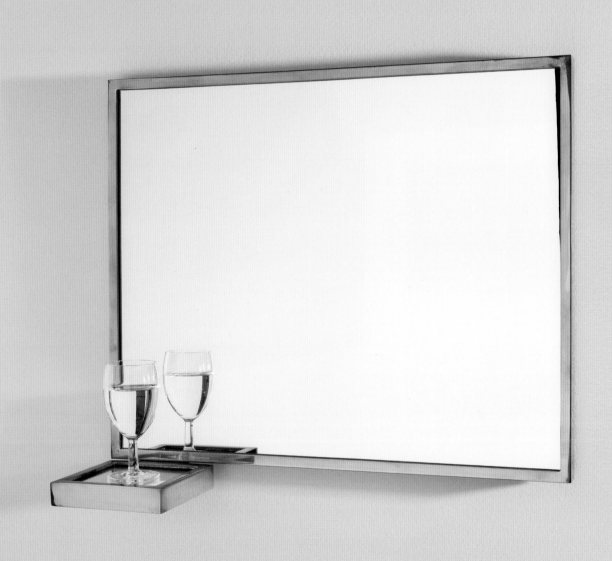

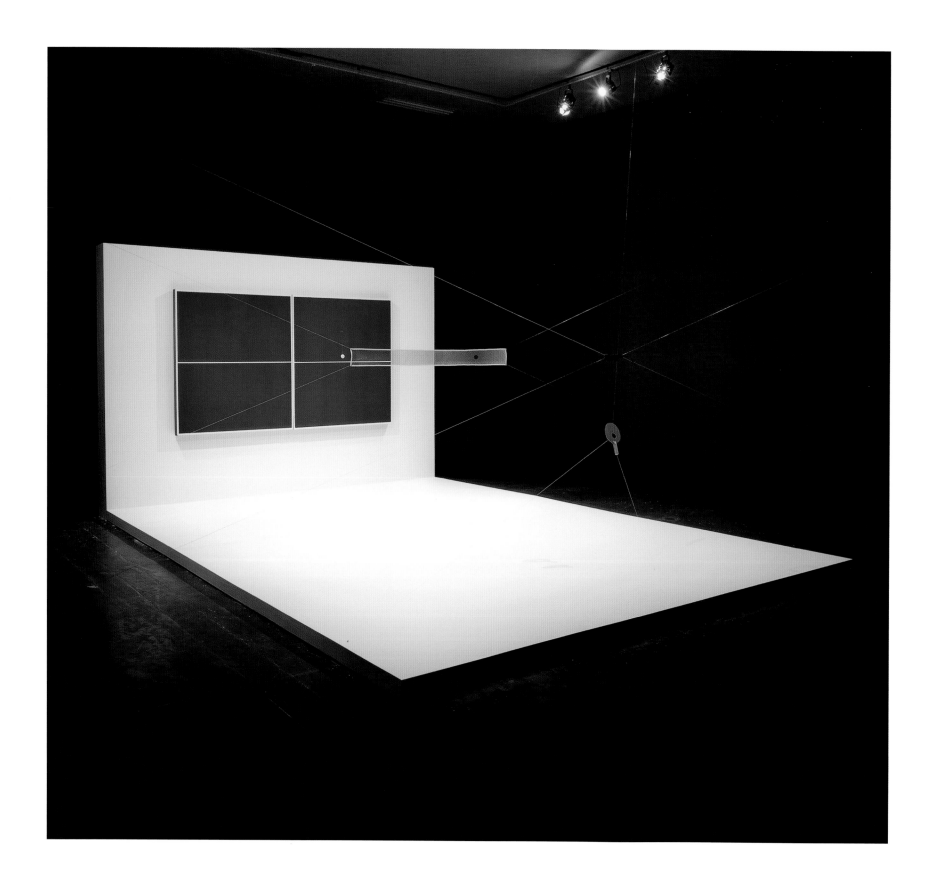

PING-PING, A CONSTRUÇÃO
DO ABISMO NO PISCAR DOS CEGOS
(*PING-PING, CONSTRUCTING THE ABYSS*
IN A BLINK OF BLINDNESS), 1980

Mixed media
244¹/₁₀ × 275³/₅ × 137⅘ in. (620 × 700 × 350 cm)

Museu de Arte Moderna do Rio de Janeiro
Collection / Sponsorship Petrobras

A EXPERIÊNCIA MONDRIAN
(*THE MONDRIAN EXPERIENCE*), 1978

Electric apparatus
5½ × 28⅜ × 8⅝ in. (13 × 72 × 22 cm)

Collection Museu de Arte Moderna de São Paulo

DESENHO (DRAWING), 2011

Acrylic paint and collage on cardboard
20 × 28¾ × 1½ in. (51 × 73 × 4 cm)

Collection Raquel Arnaud

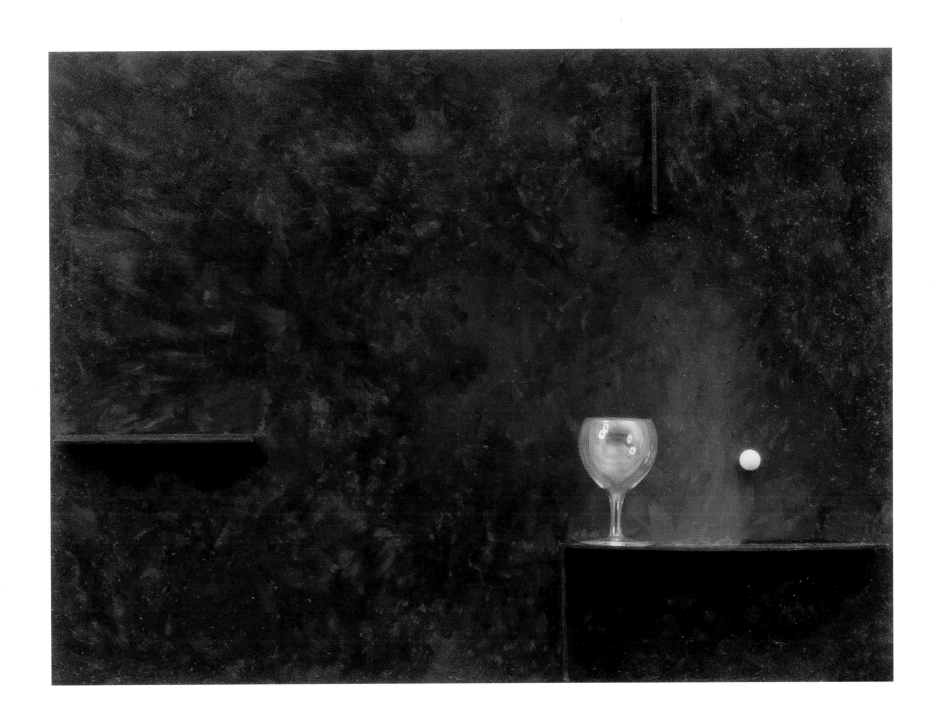

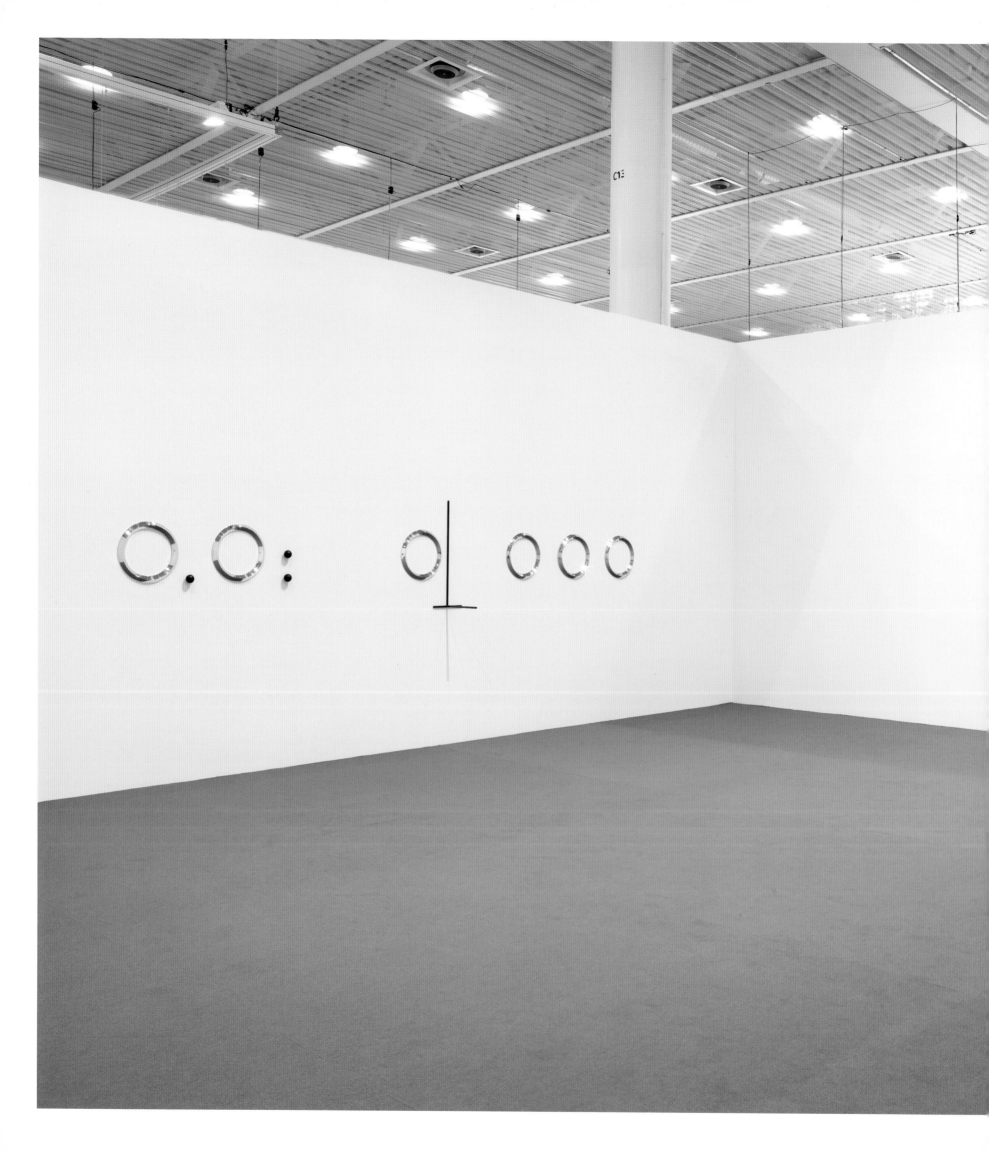

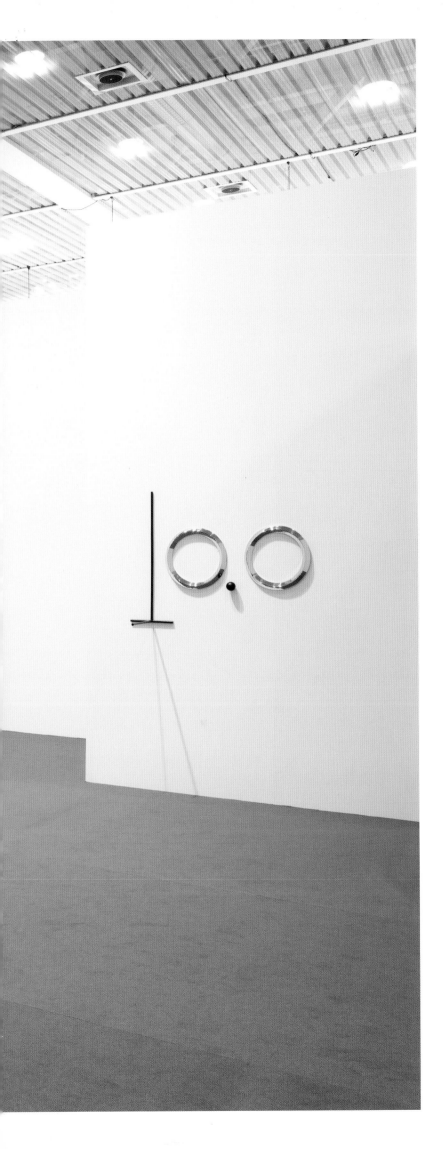

O QUE É MUNDO. O QUE NÃO É
(*WHAT IS WORLD. WHAT IS NOT*), 2011

Bronze, stainless steel, aluminum, and acrylic on wood
Dimensions variable

Private collection, Rio de Janeiro

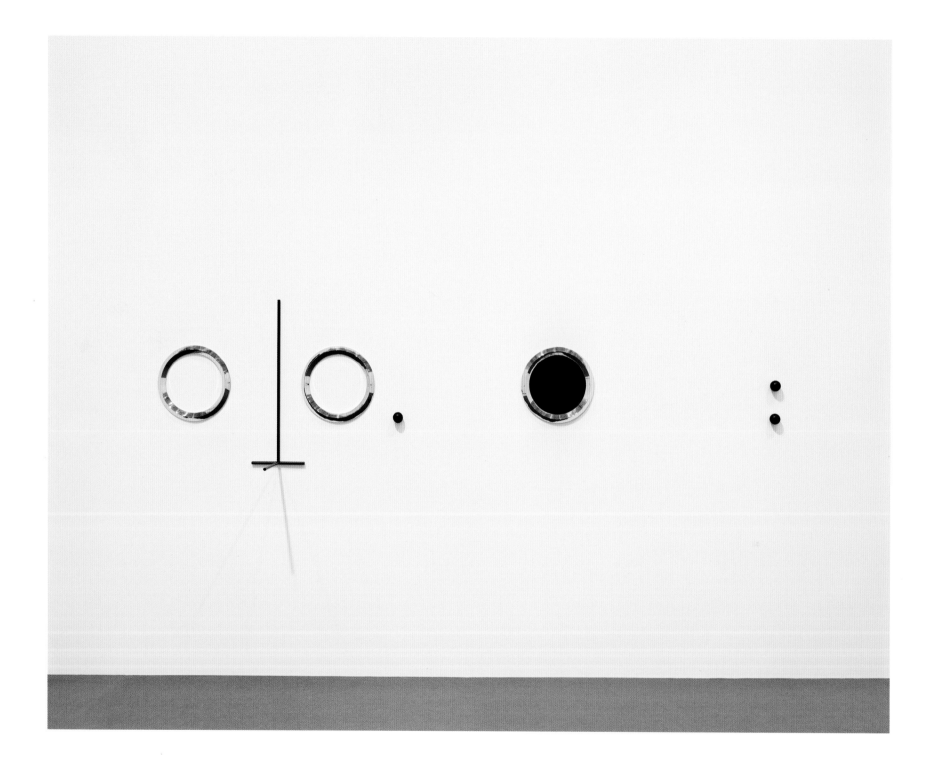

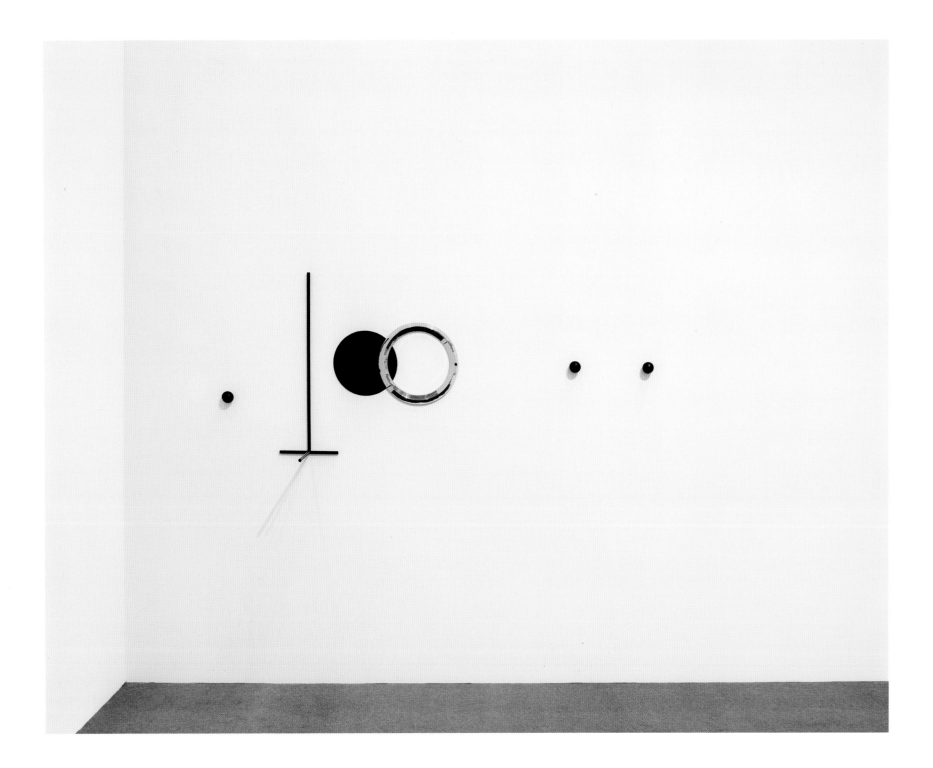

PIANO (*PIANO*), 2007

Wood and stainless steel
33⅞ × 48 × 25¼ in. (86 × 122 × 64 cm)

Colección Patricia Phelps de Cisneros, New York

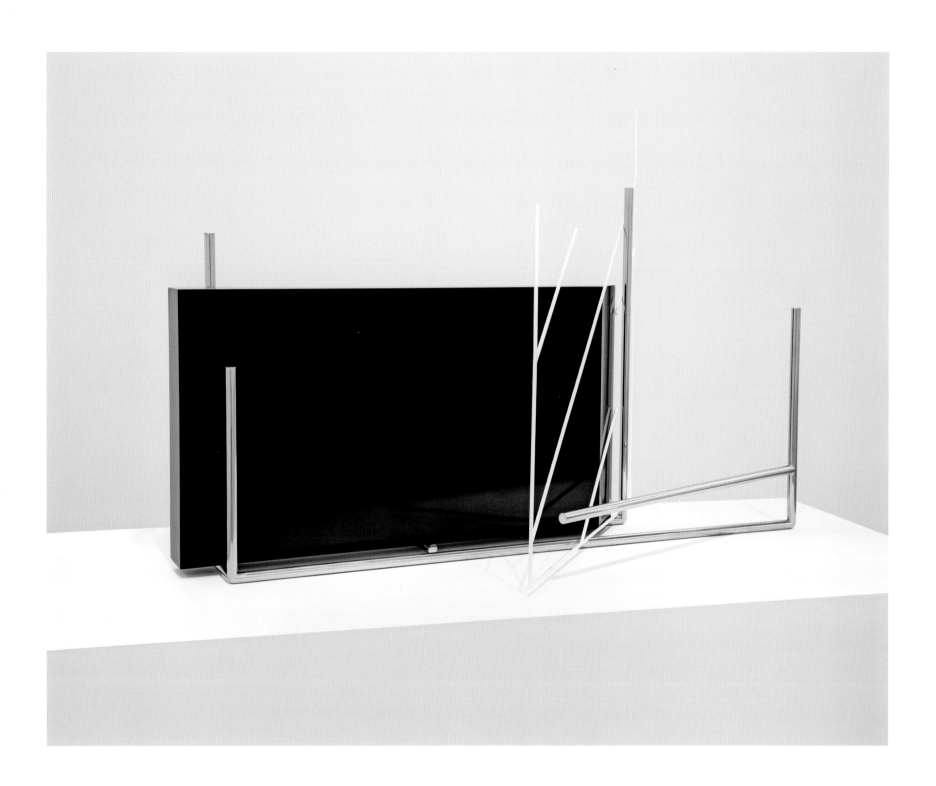

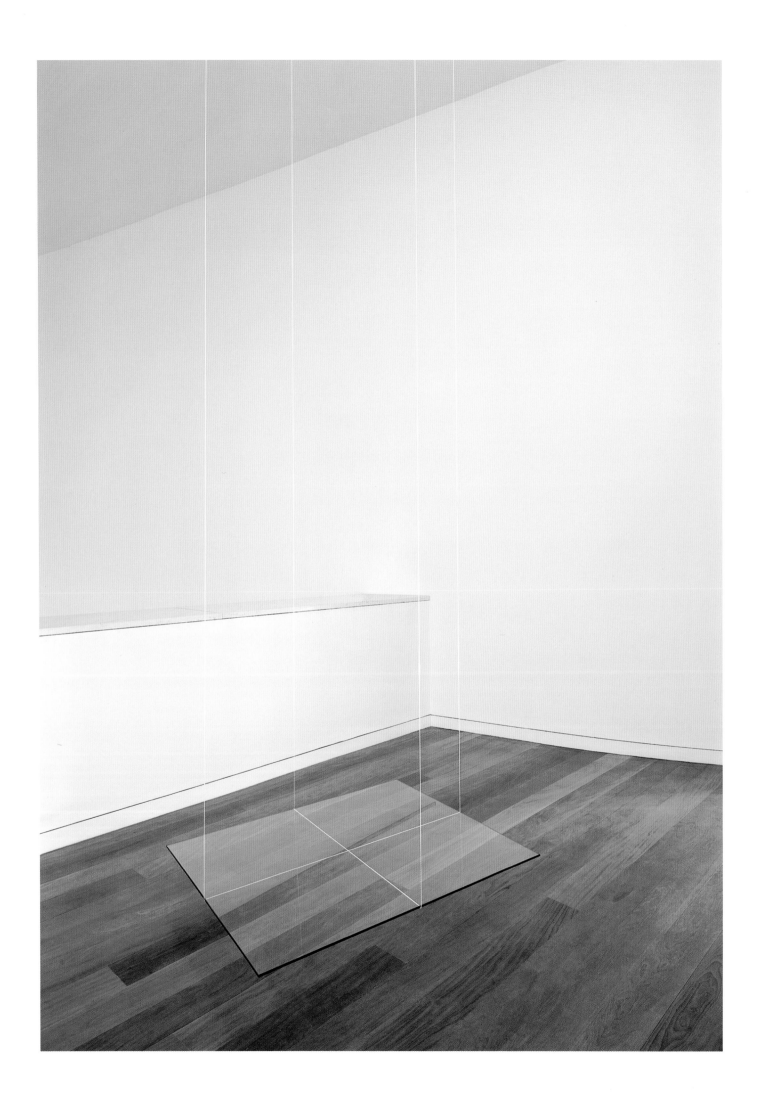

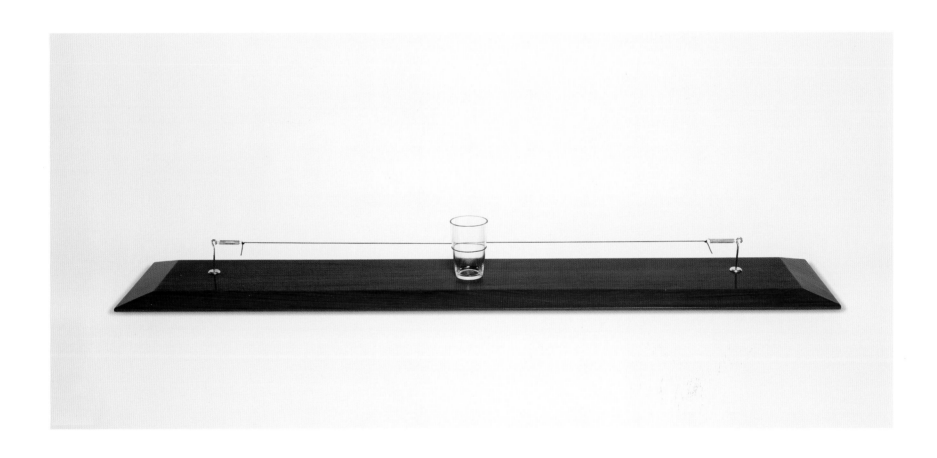

LONGÍNQUA (FAR), 1986

Glass sheet and nylon strings
39⅜ × 47¼ in. (100 × 120 cm) [variable height]

Private collection, Rio de Janeiro

ULTRAMAR (OVERSEAS), 1983

Glass, string, stainless steel, and wood
4¾ × 47¼ × 9⅞ in. (12 × 120 × 25 cm)

Private collection, Rio de Janeiro

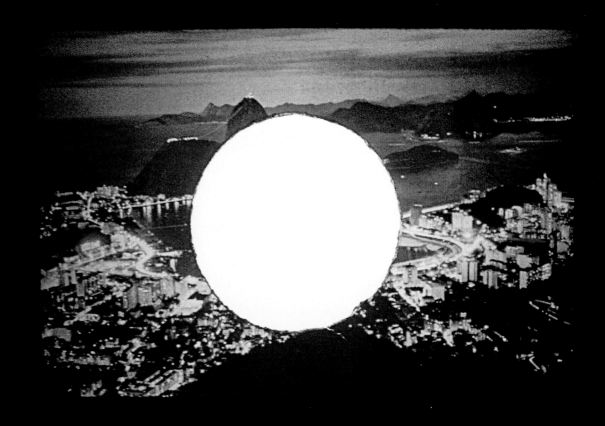

O JOGO DO ROMANCE II
(THE GAME OF ROMANCE II), 1978

Projection of pierced slides
275⅗ × 236⅓ × 137⅘ in.
(700 × 600 × 350 cm)

Private collection, Rio de Janeiro

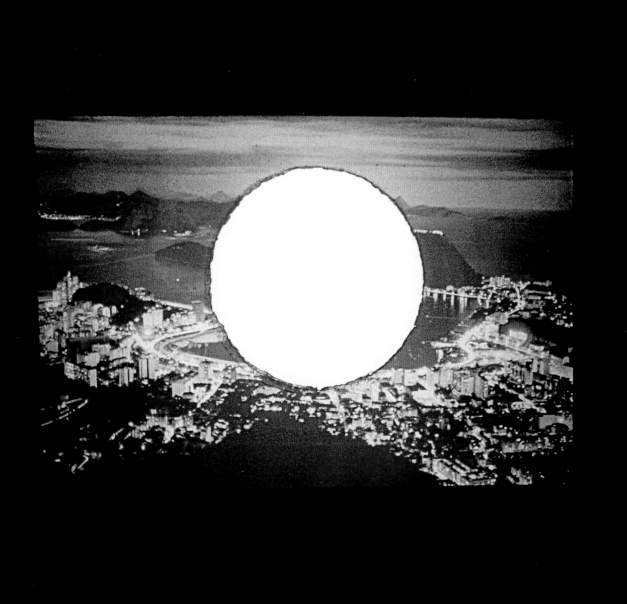

É = (O ESPELHO) UM VÉU?
(IS = (THE MIRROR) A VEIL?), 1998

Stainless steel polished ball and digital print
on paper in cardboard and cloth portfolio
15⅜ × 12⅝ × 2¾ in. (39 × 32 × 7 cm)

Private collection, Rio de Janeiro

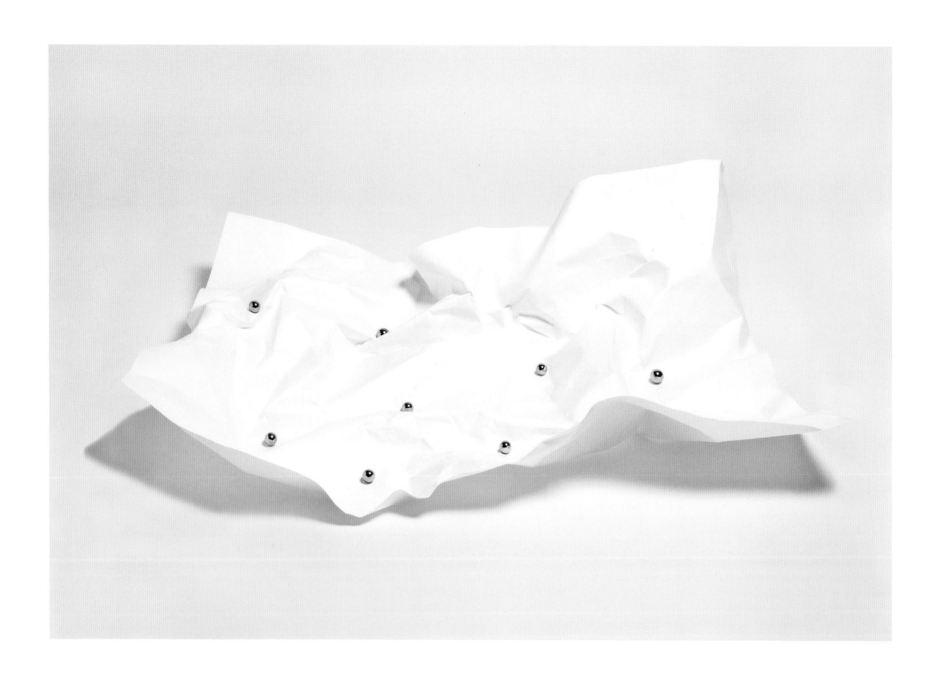

É = (IS =), 1986

Polished stainless steel balls on paper
7⅞ × 19⅝ × 27½ in. (20 × 50 × 70 cm)

MJME Collection

O LIMITÓGRAFO
(*THE LIMITOGRAPH*), 1975

Wood, metal, glass, and cork
21⅝ × 26⅜ × 5⅛ in. (55 × 67 × 13 cm)

Private collection, Rio de Janeiro

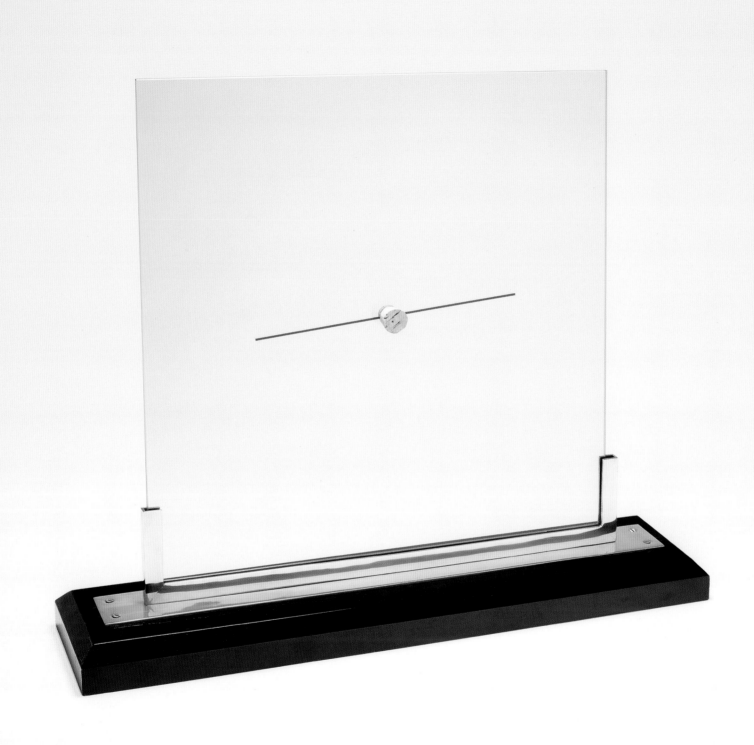

TUBOS DE FERRO PINTADOS
(*PAINTED TUBES*), 1978

Acrylic on iron
35⁷⁄₁₆ × 75⁹⁄₁₆ × ⁵⁄₁₆ in. (90 × 192 × 0.8 cm)

Private collection, Rio de Janeiro

ESCULTURA PARA TODOS OS MATERIAIS
NÃO TRANSPARENTES (SCULPTURE FOR
ALL NONTRANSPARENT MATERIALS), 1985

Pairs of polished metal, wooden, and marble hemispheres
Dimensions variable

Cacau and Gugu Steiner

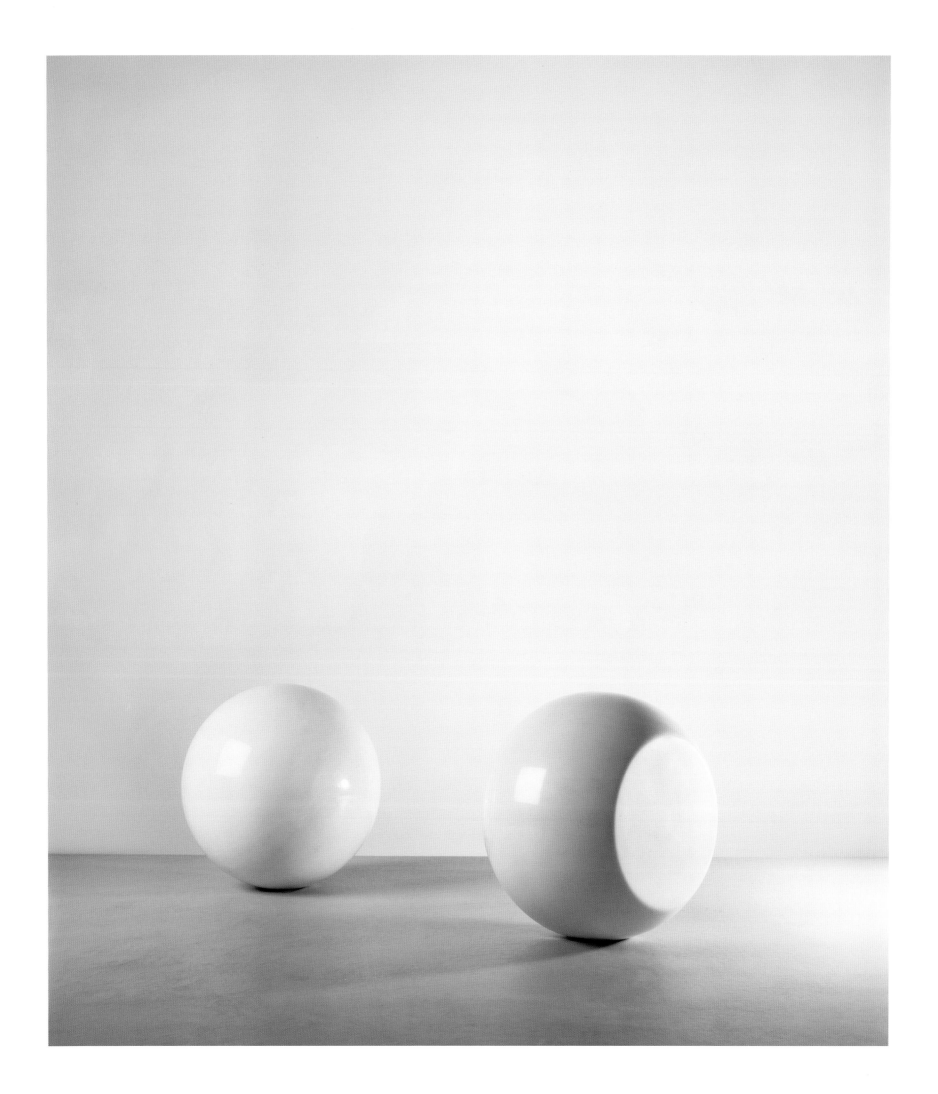

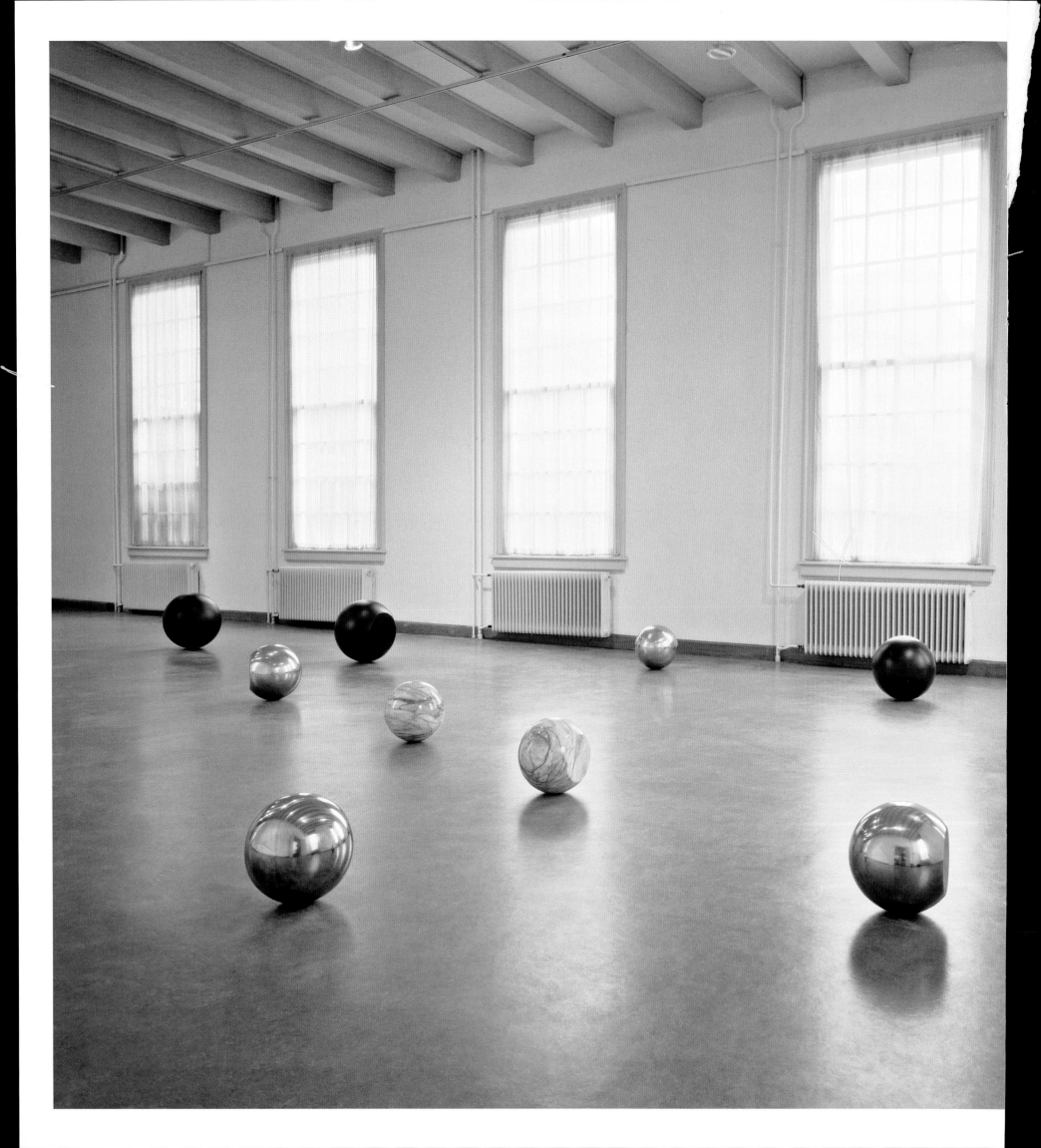

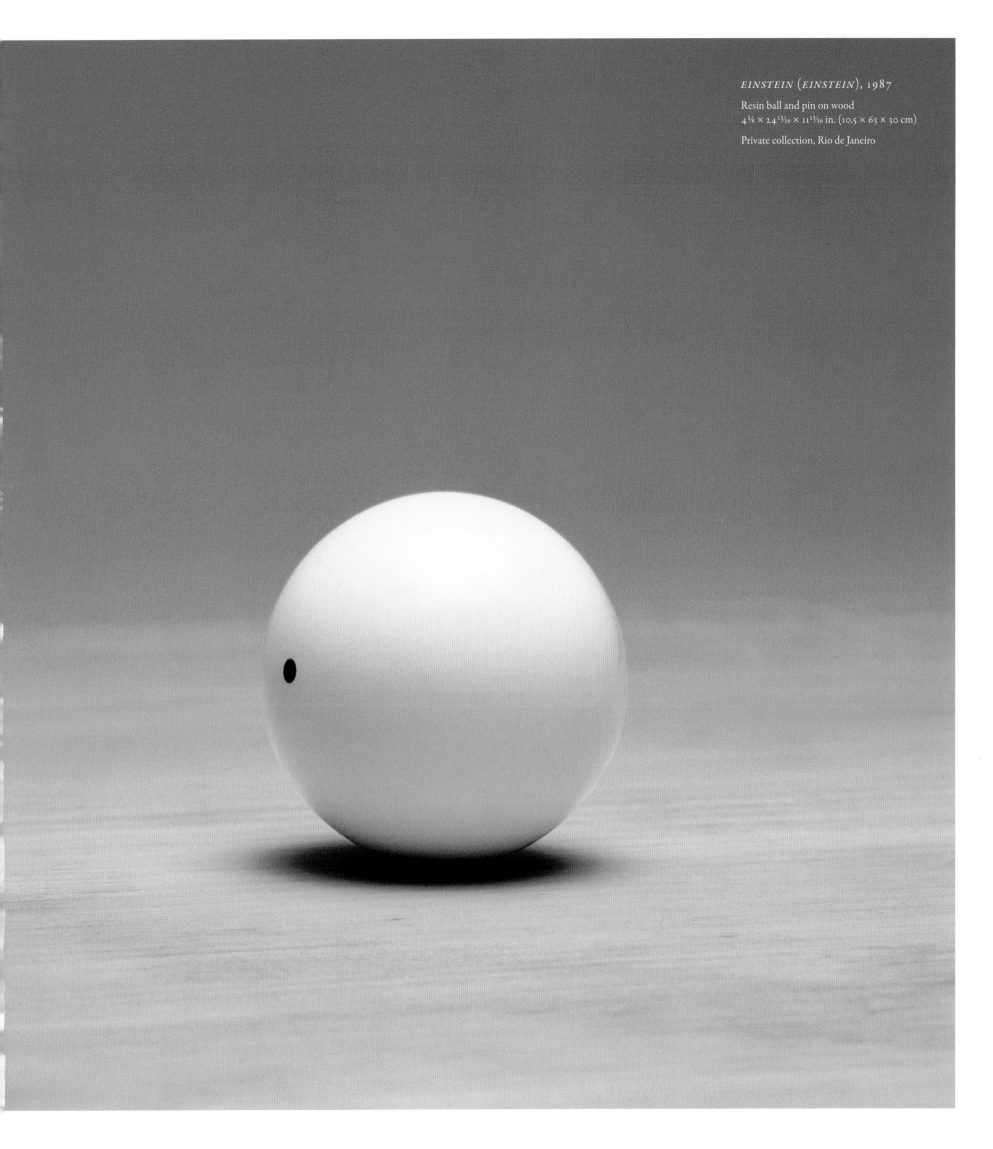

DESENHO (DRAWING), 2010

Ink and watercolor on cardboard
14 3/16 × 20 1/16 in. (36 × 51 cm)

Private collection, Rio de Janeiro

Mari Tere Rodríguez

1946 Born in Rio de Janeiro, Brazil.

1964 Studies with Ivan Serpa, an influential member of the concrete art movement, at the Museu de Arte Moderna in Rio de Janeiro (MAM/RJ). Caldas later recalled what it was like to be Serpa's student:

> We did not have formal university training in art, only a course at the Escola Nacional de Belas Artes [National School of Fine Arts], which was like the nineteenth century, more conservative, along the lines of the academy. Serpa was well informed about current [international] trends; [he was] an excellent professor because he posed many questions and made us believe that the art world was more than what newspapers and books told us; it was a world that was dynamically expanding.[1]

1967 First public exhibition of Caldas's work, in a group show at Rio de Janeiro's Galeria Gead. He wins the award in the drawing category. Exhibited works such as *Maquete I* (*Maquette I*) consist of small-scale objects with delicate lines and architectonic compositions.

1969 Creates the seminal work *Condutores de percepção* (*Perception Conductors*), a box-object that became a touchstone in his oeuvre for the way it establishes a key dynamic between the viewer and the artwork. The curator Guy Brett described the artwork in this way: "The two 'conductors' lie in their velvet box like the instruments of some fastidious science. They invite touch, they imply investigation, measurement, meaning, and yet they are transparent and void . . . Caldas's objects are "thought" objects. They tend to open up a gulf between what you see or touch, and what you think, which can be vertiginous."[2]

1971 Exhibits three box-objects at the Salão de Verão (Summer Art Salon) at MAM/RJ: *Condutores de percepção* (*Perception Conductors*), *As sete estrelas do silêncio* (*The Seven Stars of Silence*), and *Centro de razão primitiva* (*Centre for Primitive Reason*).

1973 MAM/RJ organizes Caldas's first solo exhibition, *Objetos e Desenhos* (*Objects and Drawings*), to wide critical acclaim. The Brazilian critic Ronaldo Brito noted the thought-provoking quality of the works: "[His art] is much less an object of contemplation than an active form of conveying thought, of producing a crisis in the mental habits of the viewer. In a time in which looking at art seems to be a particularly refined social engagement, the exhibition of Waltercio Caldas's works proposes a refutation: that art is not just there to look at, but to be thought about."[3]

1974 Solo exhibition *Narrativas* (*Narratives*) at Galeria Luiz Buarque e Paulo Bittencourt in Rio de Janeiro. Exhibits drawings in *Arte gráfico brasileño hoy* (*Brazilian Graphic Arts Today*), organized by Itamaraty (the Brazilian Ministry of Foreign Affairs) in Barcelona, Spain.

1975 *A Natureza dos Jogos* (*The Nature of Games*), a solo exhibition of one hundred works made between 1969 and 1975, organized by the Museu de Arte de São Paulo (MASP). Galeria Luisa Strina in São Paulo organizes the solo exhibition *Esculturas e Desenhos* (*Sculptures and Drawings*).

Becomes coeditor of *Malasartes* magazine, along with the artists Rubens Gerchman, Cildo Meireles, Luiz Paulo Baravelli, José Resende, Carlos Vergara, and Carlos Zilio; the poet Bernardo de Vilhena; and the critic Ronaldo Brito.[4] The magazine published three issues between September 1975 and June 1976. Although short-lived, *Malasartes* nonetheless became an important critical voice on the arts in Brazil.

1976 A second solo exhibition of his work, *Objetos e Desenhos* (*Objects and Drawings*), organized by MAM/RJ. Works such as *Circunferência com espelho a 30°* (*Circle with Mirror at 30°*) and *Espelho com luz* (*Mirror with Light*) demonstrate larger scales than his previous pieces and a heightened engagement with the surrounding gallery spaces. Caldas reflected on those works several years later: "The need to have a vehicle for expressing ideas was always very clear to me; I was never, so to speak, totally conceptual, even if I was sympathetic to the possibility of the art object to dematerialize—not in the sense of it losing its significance as an object, but in it losing some of its fetishized materiality. The task at the time was to defetishize, to question the aura of the fetishized object."[5]

1979 *Aparelhos* (*Apparatuses*), a solo exhibition at Galeria Luisa Strina. Commenting on works such as *Aparelho de arte* (*Art Apparatus*) and *Objeto de aço* (*Steel Object*), the critic Sheila Leirner noted, "These works do not possess the clarity of a type of functional interaction between the external body and content, and must be appreciated separately, as objects that are carriers—not generators—of relations and ideas."[6]

Publishes the book *Aparelhos*. Departing from a traditional literary format, *Aparelhos* presents itself as an art object and includes reproductions of older works as well as new works made especially for the project. The critic Zulmira Ribeiro Tavares noted the unique qualities of the book: "Volumes, surfaces, colors and figurations lose part of their original condition and gain another, originated from the book's graphic space itself . . . A new space is actually created from the book, almost bearing theatrical features."[7]

1980 Exhibits work in a solo exhibition at Galeria Saramenha and participates in the exhibition project *Espaço ABC / Funarte*, both in Rio de Janeiro.

Becomes coeditor of the project *A Parte do Fogo* (*The Part of the Fire*), along with the artists and critics Cildo Meireles, José Resende, Paulo Venancio Filho, Paulo Sérgio Duarte, Ronaldo Brito, and Tunga, among others. The project's title referred to the work of the French writer Maurice Blanchot, and the project's intention was, in the words of its writers, to establish a space in which artworks and texts could "operate" and "intervene in the cultural milieu of Brazil." Echoing Caldas's book *Aparelhos*, *A Parte do Fogo* constitutes a graphical project in which text and images together form an object that is independent of the objects they visually reproduce. Published in Rio

de Janeiro, the project issued only a single number, in March 1980.

1982 Unveils his first public sculpture, *O formato cego* (*The Blind Format*), in Paseo de las Americas, Punta del Este, Uruguay, as part of the Encuentro Internacional de Escultura al Aire Libre (International Assembly of Open-Air Sculpture).

The gallery Gabinete de Arte Raquel Arnaud in São Paulo hosts the solo exhibition *Esculturas* (*Sculptures*).

Caldas publishes his second book, *Manual da ciência popular* (*Manual of Popular Science*), which includes a text by Paulo Venancio Filho. In his preface, Caldas set out the purpose of the work:

> We are face to face with printed reproduction, this contemporary habit, a surface on which a large part of the art of our time passes. Here, in this particular case, what will take place? Objects of common knowledge will be used to provide aesthetic meanings for the quotidian, or in other words, we will wander through the senses. On this surface, in this volume titled *Manual of Popular Science*, questions will not be resolved, since its author hopes this book will have no end.

The book challenged established notions regarding the mechanical reproduction of images, calling attention to the processes involved in their transfer from one type of language to another.

1983 Participates in the Seventeenth Bienal Internacional de São Paulo with the installation *A Velocidade* (*Speed*).

1984 Solo exhibition *Esculturas* (*Sculptures*) at Galeria GB Arte, Rio de Janeiro. Participates in the First Bienal de la Habana, as well as in the

exhibition *Abstract Attitudes*—his first group exhibition in the United States—held at the Center for Inter-American Relations in New York (now the Americas Society) and at the Museum of Art of the Rhode Island School of Design.

1985 Moves to New York City, where he creates the first version of *Escultura para todos os materiais não transparentes* (*Sculpture for All Nontransparent Materials*).

1986 Returns from New York City to Rio de Janeiro. Galeria Paulo Klabin in Rio de Janeiro and Gabinete de Arte Raquel Arnaud organize simultaneous exhibitions titled *Esculturas* (*Sculptures*), each consisting of different iterations of *Sculpture for All Nontransparent Materials*. Exhibits two works as part of *A nova dimensão do objeto* (*The New Dimension of the Object*), a group exhibition at the Museu de Arte Contemporânea da Universidade de São Paulo.

1987 Participates in two exhibitions at the Nineteenth Bienal Internacional de São Paulo: *Imaginarios Singulares* (*Singular Imageries*) and *Em busca da essência—elementos de redução na arte brasileira* (*In Search of the Essence—Reductive Elements in Brazilian Art*). Also exhibits in *Modernité—Art brésilien du XXe siècle* (*Modernity—Brazilian Art of the Twentieth Century*) at the Musée d'Art Moderne in Paris.

1988 Two solo exhibitions in Rio de Janeiro: *Esculturas* (*Sculptures*) at Galeria Sergio Milliet/Funarte and *Quatro esculturas curvas* (*Four Curved Sculptures*) at Galeria Paulo Klabin.

1989 Participates in the *Arte em Jornal* (*Art on Newspaper*) exhibition at the Twentieth

Bienal Internacional de São Paulo. Gabinete de Arte Raquel Arnaud hosts the solo exhibition *Esculturas* (*Sculptures*).

Unveils *Software*, a temporary public installation in Vale do Anhagabau, São Paulo, and *O jardim instantâneo* (*Instant Garden*), a permanent public sculpture in Parque do Carmo, São Paulo.

1990 First solo show in Europe opens at the Pulitzer Art Gallery in Amsterdam. Participates in the exhibition *Transcontinental: An Investigation of Reality; Nine Latin American Artists* at the Ikon Gallery in Birmingham and the Corner House Gallery in Manchester. The curator, Guy Brett, described the quality of Caldas's works: "Caldas's objects are as much 'not there' as 'there.' It is hard to answer with certainty whether they are art objects, or simply objects. They seem to want to be neither. Caldas creates a spare, calm, pure space. Is our attention intended to fall on the objects, or on the space? Are these simply 'objects between spaces'? Caldas himself has said: 'I would like to produce an object with the maximum presence and the maximum absence.'"[8]

Galeria 110 Arte Contemporânea in Rio de Janeiro hosts the solo exhibition *Desenhos* (*Drawings*). The Museu de Arte de Brasília awards him the Prêmio Brasília de Artes Plásticas (Brasília Visual Art Award).

1991 A second solo exhibition in Europe takes place at the Kanaal Art Foundation in Kortrijk, Belgium. Gabinete de Arte Raquel Arnaud hosts the solo exhibition *Esculturas e Desenhos* (*Sculptures and Drawings*).

1992 The Stedelijk Museum Schiedam in Schiedam, the Netherlands, organizes the solo exhibition *Sculpturen en Tekeningen* (*Sculptures and Drawings*). Caldas is invited to participate in documenta 9, for which he creates the installation *Raum für den nächsten Augenblick* (*Space for the Next Moment*).

1993 The Museu Nacional de Belas Artes in Rio de Janeiro organizes the first large survey of his work in Brazil, *O ar mais próximo* (*The Nearest Air*), which wins the Mario Pedrosa Prize for Exhibition of the Year, awarded by the Associação Brasileira de Críticos de Arte (Association of Brazilian Art Critics).

Caldas's work is included in *Latin American Artists of the 20th Century*, held at the Museum of Modern Art, New York (MoMA) and the Joseph Hanbrich Kunsthalle, Cologne, Germany. He also participates in *Brasil: Segni d'Arte—Libri e video, 1950–1993* (*Brazil: Art Signs—Books and Video, 1950–1993*), organized by the Fondazione Scientifica Querini Stampalia, Venice, Italy.

1994 Unveils the public sculpture *Omkring* (*Around*) in Leirfjord, Norway. His sculptures are featured in a solo exhibition at the Gabinete de Arte Raquel Arnaud. His drawings *Africa*, *India*, and *Japão* (all from 1972) are included in *Mapping*, an exhibition organized by MoMA.

1995 Solo exhibitions at the Centre d'Art Contemporain, Geneva, Italy, and Joel Edelstein Arte Contemporânea, Rio de Janeiro. His work is included in a number of group exhibitions, including two in New York: *Drawing on Chance* at MoMA and *Art from Brazil in New York* at Galerie Lelong.

1996 Featured as the sole artist representing Brazil at the Twenty-Third Biennale di Venezia, with the exhibition *Esculturas* (*Sculptures*), which includes works from the 1970s and 1980s, as well as new works such as *Gládio* (*Dagger*) and *A matéria tem dois corações* (*Matter Has Two Hearts*).

The Paço Imperial in Rio de Janeiro hosts the solo exhibition *Anotacões, 1969–1996* (*Notes, 1969–1996*), which includes sketches displayed to the public for the first time. He unveils the public sculpture *Escultura para o Rio* (*Sculpture for Rio*) on Avenida Presidente Antônio Carlos.

Publishes the book *Velázquez*; the critic and art historian Isobel Whitelegg described Caldas's treatment of Velázquez's paintings: "At the same time this book functions as an erudite exploration of Velazquez's construction of space; the removal of the human protagonist in each image reflexively reveals how the painter structured each image in order to place the protagonist at the centre of the viewer's attention. By virtue of their absence, the key figures of each painting are unavoidably there: albeit via the substitutive action of memory and imagination."[9]

1997 Two solo exhibitions: *New Sculptures* at the Quintana Gallery, Miami, and *Esculturas* (*Sculptures*) at Galería Javier Lopes in Madrid. Participates in the Forty-Seventh Biennale di Venezia and the First Bienal do Mercosul in Porto Alegre. Unveils the public sculpture *Espelho sem aço* (*Unmirrored*) on Avenida Paulista, São Paulo.

Publishes the book *Desenhos* (*Drawings*), which features twenty silk screens. His drawings are included in *Re-Aligning Vision* at the Huntington Gallery at the University of Texas at Austin (now the Blanton Museum of Art), the Museo del Barrio, New York, and the Miami Art Museum. The exhibition curator, Mari Carmen Ramírez, described Caldas's drawing style: "These drawings stand out for their minimal use of soft, simple lines arranged in phrase-like formats. Despite

their apparent effortlessness, however, each one of these drawings is the result of numerous sketches whose purpose is to capture something close to the essence of movement or gesture itself. By repeating the movement of the hand over and over again, the artist achieves something close to a perfect trace congealed in time."[10]

1998 Two solo exhibitions in Rio de Janeiro: *A Série Venezia* (*The Venice Series*) at Centro Cultural Light and *Esculturas* (*Sculptures*) at Galeria Paulo Fernandes. *Sculptures* goes on display at Galerie Lelong in New York City. Completes an untitled sculpture for permanent display at the Museu de Arte Moderna in Bahia.

1999 The solo exhibition *Livros* (*Books*) opens at MAM/RJ and travels to Casa da Imagem, Curitiba, and the Museu de Arte da Pampulha, Belo Horizonte. The Christopher Grimes Gallery in Santa Monica hosts the solo exhibition *Sculptures*. Reflecting on Caldas's work that year in *Arte internacional brasileira* (*Brazilian International Art*), the art historian Tadeu Chiarelli described the antagonism sometimes evident between Caldas's work and both the art world and the viewing public:

> His sculptures in wood, glass, alcohol and metal attest to the formal rigor always present in their production and, at the same time, the vitriol with which he often stood in relation to art and its circuit . . . His sculptures interrogate the rigors of geometry applied to the medium; they criticize the physical participation of the public in appreciation of the work (the pieces of glass, if touched, may simply shatter), and when approaching design—one of constructivism's utopias—they disrupt the concept of functionality.[11]

His work is included in *Global Conceptualism: Points of Origin, 1950s–1980s* at the Queens Museum of Art, New York, and the Walker Art Center, Minneapolis.

2000 The solo exhibition *Uma Sala para Velázquez* (*A Room for Velázquez*) opens at the Museu de Belas Artes, Rio de Janeiro. Two other solo exhibitions, both titled *Esculturas e Desenhos* (*Sculptures and Drawings*), take place at Celma Albuquerque Galeria de Arte in Belo Horizonte and the Galeria Laura Marsiaj Arte Contemporânea in Rio de Janeiro.

Unveils the public sculpture *Momento de Fronteira* (*Border Moment*) in Itapiranga, Santa Catarina, on the border between Brazil and Argentina.

2001 Centro Cultural Banco do Brasil in Rio de Janeiro organizes the retrospective exhibition *Retrospectiva, 1985/2000* (*Retrospective, 1985/2000*). The critic Paulo Sérgio Duarte described the philosophical underpinnings of Caldas's works:

> In expanding the field of the gaze and exploring a purely optical intelligence, Waltercio's art rarely carries any sort of rhetoric—there is always a residue of skepticism, in which questions present themselves with a twist: a pleasant doubt. Challenging the positivist logic that underpins quotidian rationale and its praise of what is conventionally termed "results," these exercises insist on contradicting common sense . . . Their existential dimension unfolds in a chain of processes of successive retinal enigmas, in the promise that if we do not cease to use our intelligence, it is indeed possible to live within reality, despite its brutality and its absurd appearance.[12]

2002 The Pinacoteca do Estado de São Paulo and the Museu de Arte do Rio Grande do Sul host the exhibition *Livros* (*Books*). The Torreão Porto Alegre organizes the solo exhibition *Frases Sólidas* (*Solid Phrases*).

2003 Two solo exhibitions: *Sculptures* at the Christopher Grimes Gallery in Santa Monica and *Desenhos* (*Drawings*) at Galeria Artur Fidalgo, Rio de Janeiro.

2004 Solo exhibition at the Gabinete de Arte Raquel Arnaud. His work is included in *Latin American and Caribbean Art: MoMA at El Museo*, in New York. Of Caldas's oeuvre, the curator, Luis Pérez-Oramas, wrote: "Caldas . . . has engaged in a constant interrogation of a single action: the spectator's confrontation with the artwork. He is perfectly aware of his place in art history, and of his work's instrumental role in the contemporary Latin American art scene."[13]

Unveils the public sculpture *Espelhos Ausentes* (*Absent Mirrors*) in Rio de Janeiro.

2005 Two solo exhibitions: *The Black Series* at the Christopher Grimes Gallery in Santa Monica and *Sculptures et dessins* (*Sculptures and Drawings*) at Galerie Denise René Rive Gauche, Paris. Participates in the Fifth Bienal do Mercosul and in the group exhibition *Beyond Geometry* at the Los Angeles County Museum of Art and the Miami Art Museum.

Unveils the public sculpture *Espelho Rápido* (*Fast Mirror*) in Porto Alegre.

2006 Publishes the books *Notas, () etc.* [*Notes, () etc.*] and *Atelier Transparente* (*Transparent Atelier*). His sculptures are showcased at solo exhibitions at Galeria Laura Marsiaj Arte

Contemporânea, Rio de Janeiro, and at Celma Albuquerque Galeria de Arte, Belo Horizonte, Brazil.

2007 Solo exhibitions at Galeria Artur Fidalgo, Rio de Janeiro, and Galeria Elvira González, Madrid. Participates in the Fifty-Second Venice Biennial with the work / Pensa con i sens/, sent/ con la mente (*Half Mirror Sharp*).

2008 Two solo exhibitions: *Horizontes* (*Horizons*) at the Fundação Calouste Gulbenkian, Lisbon, and *Mais Lugares* (*More Places*) at Centre Galego de Arte Contemporánea, Santiago de Compostela, Spain. Participates in international group exhibitions, including *Face to Face* at the Daros Collection, Zurich, and *Lines, Grids, Stains, Work*, organized by MoMA and subsequently held at the Museu de Arte Contemporânea de Serralves, Porto, Portugal, and Museum Wiesbaden, Wiesbaden, Germany.

2009 The solo exhibition *Salas e Abismos* (*Rooms and Abysses*) opens at the Museu Vale, Espírito Santo, Brazil, and travels to MAM/RJ.

2010 Anita Schwartz Galeria de Arte in Rio de Janeiro organizes the solo exhibition *Waltercio Caldas*. Participates in *Olhar do Colecionador: Coleção Tuiuiu* (*The Collector's Eye: Tuiuiu Collection*) at the Instituto de Arte Contemporânea, São Paulo.

2011 The solo exhibition *A Série Negra* (*The Black Series*) opens at Galeria Raquel Arnaud (previously Gabinete de Arte Raquel Arnaud). Participates in Art Basel's *Art Unlimited 2011* and in the group exhibition *Underwood* at Galerie 1900/2000, Paris. Collaborates on the initiative

Aberto Brasília: Intervencões Urbanas (*Open Brasilia: Urban Interventions*) with the work *Eixo Monumental* (*Monumental Axis*).

2012 Participates in the group exhibition *Notations: The Cage Effect Today* at the Hunter College Times Square Gallery, New York. Creates *Parábolas de superfícies* (*Parabolas of Surfaces*) for the Eleventh Bienal de Cuenca, where he wins the event's top prize. In Rio de Janeiro, Mul.ti.plo Espaço Arte hosts an exhibition of his recent engravings and serial work, and the Fundação Casa França-Brasil organizes the solo exhibition *Panoramas*.

The largest career survey of his oeuvre, *O ar mais próximo e outras matérias*, opens at the Fundação Iberê Camargo, Porto Alegre, and travels to the Pinacoteca do Estado de São Paulo. The exhibition features more than eighty works spanning five decades. In 2013 it traveled to the Blanton Museum of Art, Austin, with the title *The Nearest Air: A Survey of Works by Waltercio Caldas*.

NOTES

1. Quoted in Adolfo Montejo Navas, "A la búsqueda del desnudo necesario," *Lápiz* (Spain) 20, no. 174 (2001): 42. All translations from the Spanish and Portuguese are by the author.

2. Guy Brett, "Waltercio Caldas," in *Transcontinental: An Investigation of Reality; Nine Latin American Artists* (London: Verso, 1990), 70.

3. Ronaldo Brito, "Racional e absurdo," *Opinião*, no. 41 (August 1973): 24. Cited in Ligia Canongia, "Cronologia," in *Waltercio Caldas, 1985–2000* (Rio de Janeiro: Centro Cultural Banco do Brasil, 2000), 178, 180.

4. *Malasartes*, nos. 1–3, Rio de Janeiro (1975–1976).

5. Montejo Navas, "A la búsqueda del desnudo necesario," 42.

6. Sheila Leirner, *Folha de São Paulo*, April 21, 1979.

7. Zulmira Ribeiro Tavares, "Ironia e sentido," *Módulo*, no. 61 (November 1980).

8. Brett, *Transcontinental*, 70.

9. Isobel Whitelegg, "O livro Velázquez," Essex Collection of Latin American Art, accessed July 10, 2012. http://www.escala.org.uk/collection/artists /waltercio-caldas/AUTH98/0-livro-velazquez /O307.

10. Mari Carmen Ramírez, "Waltercio Caldas," in *Re-aligning Vision: Alternative Currents in South American Drawing* (Austin: Archer M. Huntington Art Gallery, Univ. of Texas at Austin, 1997), 132.

11. Tadeu Chiarelli, *Arte internacional brasileira* (São Paulo: Lemos, 1999), 226–227.

12. Paulo Sérgio Duarte, "Interrogações construtivas," in Canongia, *Waltercio Caldas*, 64–65.

13. Luis Pérez-Oramas, "Waltercio Caldas' *Mirror of Light* and Cildo Meireles' *Thread*," in *Latin American and Caribbean Art: MoMA at El Museo* (New York: El Museo del Barrio and the Museum of Modern Art, 2004), 139.

DESENHO (DRAWING), 1975

Ink and watercolor on cardboard
14⅜ × 20⅕ in. (36.5 × 51.3 cm)

Private collection, Rio de Janeiro

WRITINGS BY THE ARTIST

Aparelhos. Rio de Janeiro: GBM Editora, 1979.

A contrução do abismo. Rio de Janeiro: Galeria Saramenha, May 1980. Exhibition catalogue.

O livro mais rápido. São Paulo: Gabinete de Arte Raquel Arnaud, September 1982.

Manual da ciência popular. Text by Paulo Venancio Filho. Rio de Janeiro: Edição Funarte, 1982. Rev. ed., São Paulo: Cosac Naify, 2007.

"É = um véu." *Guia das Artes* 17 (1989), 44–49.

Anotações, 1969–1996. Rio de Janeiro: Projeto Finep / Ateliê Contemporâneo, 1996. Exhibition catalogue.

O livro Velázquez. São Paulo: Editora Anônima, 1996.

Desenhos. Rio de Janeiro: Reila Gracie Editora, 1997.

Atelier Transparente. Belo Horizonte: Editora C/Arte, 2006.

Notas, () etc. São Paulo: Gabinete de Arte Raquel Arnaud, 2006.

Outra fabula. São Paulo: Cosac Naify, 2011.

Cronometrias. Rio de Janeiro: Lithos Edicões de Arte, 2012.

WORKS ABOUT THE ARTIST

Arestizábal, Irma. *Precisão: Amilcar de Castro, Eduardo Sued, Waltercio Caldas*. Rio de Janeiro: Centro Cultural Banco do Brasil, 1994. Exhibition catalogue.

Brett, Guy. *Transcontinental: An Investigation of Reality; Nine Latin American Artists*. London: Verso, 1990.

Brito, Ronaldo. "Clear bias." In *Waltercio Caldas: Sculpturen en tekeningen*. Kortrijk, Belgium: Kunststuching Kanaal Art Foundation, 1991. Exhibition catalogue.

———. "O espelho crítico." In *Waltercio Caldas Junior: "A natureza dos jogos."* São Paulo: Museu de Arte de São Paulo, 1975. Exhibition catalogue.

———. *Waltercio Caldas Jr.: "Aparelhos."* Rio de Janeiro: GBM Editora, 1979.

———. "Waltercio Caldas Jr.—Aparelhos." *A parte do Fogo*, April 1980.

Calábria, Roberta. "Rarefied." In *As esculturas ao aire libre de Waltercio Caldas*, 119–125. Santiago de Compostela: Xunta de Galicia, 2009.

Canongia, Ligia. "Entrevista com Waltercio Caldas." In *Mar nunca nome*. Rio de Janeiro: Centro Cultural Light, 1998. Exhibition catalogue.

Chiarelli, Tadeu. "Para que Duchamp? Ou: sobre alguns trabalhos de Waltercio Caldas." In *Por que Duchamp? Leituras duchampianas por artistas e críticos brasileiros*. São Paulo: Itaú Cultural, 1999.

Cocchiarale, Fernando. "Visão de um tempo suspenso." *Galeria* 17 (1989).

Coutinho, Wilson. "A ausência de Velásquez." *O Globo*, August 21, 1996.

———. "O riso contra a verdade." *Arte Hoje* 8 (1978).

DJW. "Tekeningem van Waltercio Caldas in het Kortrijks kultureel centrum." In *Her Nieuwsbald* (Belgium), November 12, 1991.

Duarte, Paulo Sergio. *Anos 60—transformações da arte no Brasil*. Rio de Janeiro: Campos Gerais Edição e Comunicação Visual, 1998.

———. "Constructive Interrogations." In *Waltercio Caldas*. Translated by Ann Puntch and Heloisa Prieto. São Paulo: Gabinete de Arte Raquel Arnaud, 1994. Exhibition catalogue.

———. "Doppo Seurat." In *Salas e Abismos*, 220–222. São Paulo: Cosac Naify, 2009. Catalogue of an exhibition at the Museu Vale. Duarte's essay was first published on a poster displayed as part of Caldas's *A velocidade* (*Speed*), which was shown in its own room at the Seventeenth Bienal Internacional de São Paulo, 1983.

———. "Entre o clássico e o contemporâneo." *O Estado de S. Paulo*, October 29, 1994.

———. "Interrogações construtivas." In *Waltercio Caldas, 1985–2000*. Rio de Janeiro: Centro Cultural Banco do Brasil, 2000.

———. "Livro-objeto." *Jornal do Brasil*, August 14, 1999.

———. "Ping-Ping: Alluding to the Fault." In *Salas e Abismos*, 217–219. São Paulo: Cosac Naify, 2009. Catalogue of an exhibition at the Museu Vale.

———. "Waltercio contraria todas as normas do mundo." *Ilustrada, Folha de S. Paulo*, October 24, 1996.

Duarte, Paulo Sergio, and Waltericio Caldas. *Waltericio Caldas*. São Paulo: Cosac Naify, 2001.

———. *Waltercio Caldas: Desenhos*. Rio de Janeiro: Galeria 110 Arte Contemporânea, 1990. Exhibition catalogue.

Farias, Agnaldo Aricê Caldas. "Esculpindo o espaço / A escultura contemporânea e a busca de novas relações com o espaço: Os casos Waltercio Caldas e Carlos Fajardo." PhD diss., Faculdade de Arquitetura e Urbanismo, Universidade de São Paulo, 1997.

———. "Waltercio Caldas: A consciência do intervalo." In the general catalogue for the Twenty-Third Bienal Internacional de São Paulo, 1996, 74–79.

Ferraz, Heitor. "Waltercio Caldas: O poeta do objeto." *Arte 21* (December 1996): 10–13. Interview with the artist.

Filho, Antonio Gonçalves. "Waltercio incorpora o tempo na escultura." *Ilustrada, Folha de S. Paulo*, October 17, 1991.

———. "Waltercio introduz o inmaterial na escultura." *Ilustrada, Folha de S. Paulo*, July 7, 1992.

Filho, Paulo Venancio. "Even More than Before." In *Horizontes*, 136–141. Lisbon: Centro de Arte Moderna José de Azeredo Perdigão—Fundação Calouste Gulbenkian, 2008–2009. Exhibition catalogue.

———. "Melting Space." In *Salas e Abismos*, 212–216. São Paulo: Cosac Naify, 2009. Catalogue of an exhibition at the Museu Vale.

———. "Not." In *Waltercio Caldas*. São Paulo: Armazénes Gerais Columbia, 1992. Published on the occasion of documenta 9, Kassel, Germany.

———. "Olho de vidro." In *Aparelhos*. Rio de Janeiro: Galeria Luisa Strina, 1979. Exhibition catalogue.

———. "Protocolo poético." *Guia das Artes* 30 (November– December 1992).

Flores, Cristine Monteiro. "Sinfonia em branco: Waltercio Caldas e a poético do silêncio." In *Memória e esquecimento na arte*, edited by Maria Clara Armando Martins and Carlos Eduardo Valente. Rio de Janeiro: Museu Nacional de Belas Artes, 1995.

———. "Waltercio Caldas: A arte de tecer o ar." Master's thesis, Universidade Federal do Rio de Janeiro, Centro de Letras e Artes, Escola de Belas Artes, 1998.

Freitas, Iole de. "A transparência." *Jornal de Resenhas, Folha de S. Paulo*, April 11, 1998.

Herkenhoff, Paulo. "Around the Tropical Arctic." In

Skulpturlandskap Nordland, edited by Maaretta Jaukkuri, 46–49. Kiese, Norway: Forlaget Geelmuyden, 1999.

———. "Waltercio Caldas, Jac Leirner e a densidade da história da arte no Brasil." In *XLVII Bienal de Veneza: Representaçao Brasiliera*. São Paulo: Fundação Bienal de São Paulo, 1997. Catalogue of Brazil's representation in the Venice Biennial.

Johnson, Ken. "Waltercio Caldas." *New York Times*, January 8, 1999.

Kuijken, Ilse. "Talking Back (to Art)." In *Waltercio Caldas*. São Paulo: Armazénes Gerais Columbia, 1992. Published on the occasion of documenta 9, Kassel, Germany.

Lagnado, Lisette. "Silent Processes . . ." *Artforum*, November 1996.

———. "Waltercio Caldas Jr., o, 1, 2 . . ." *Arte em São Paulo*, October 1982.

Larsen, Bente. "Distance." In *Skulpturlandskap Nordland*, edited by Maaretta Jaukkuri. Kiese, Norway, Forlaget Geelmuyden, 1999.

Leirner, Sheila. "Desafio ao convencional na construção do objeto pleno." In *Arte como medida*. São Paulo: Editora Perspectiva, 1982.

———. "As imagens do cotidiano e a pureza do ato poético." *O Estado de S. Paulo*, July 6, 1982.

———. "Um desafio ao convencional na construção do objeto pleno." *O Estado de S. Paulo*, April 21, 1979.

Lodermeyer, Peter, Karlyn de Jongh, and Sarah Gold. "Waltercio Caldas." In *Personal Structures: Time—Space—Existence*, 384–387. Amsterdam: DuMont Buchverlag.

Mammì, Lorenzo. "Waltercio Caldas." In *Esculturas e deshenhos*. Rio de Janeiro: Galeria Joel Edelstein Arte Contemporânea, 1995. Exhibition catalogue.

Matthesszel, Beszélgetés Axes. "Hérakleitosz a Kortársam, Günter Grass Pedig Nem." *Nappali báz Magazine* (Hungary) 3 (1992).

Mello Mourão, Gerado de. "Os aparelhos da Arte." *Folha de S. Paulo*, October 29, 1979.

Molder, Jorge. "'Things' and Circulation." In *Horizontes*, 134–135. Lisbon: Centro de Arte Moderna José de Azeredo Perdigão—Fundação Calouste Gulbenkian, 2008–2009. Exhibition catalogue.

Navas, Adolfo Montejo. "Waltercio Caldas." *Lápiz* (Spain) 18, no. 156 (1999).

Naves, Rodrigo. "Aparelhos." *Leia Livros, Folha de S. Paulo*, August 1979.

———. "De papel." *Módulo*, 1982.

———. "Dois pontos." In *o é Um*. Rio de Janeiro: Projeto ABC, Parque da Catacumba, 1980. Exhibition catalogue.

Olveira, Manuel. "Open-Air Sculpture: Sizing up the Situation." In *As esculturas ao aire libre de Waltercio Caldas*, 103–108. Santiago de Compostela: Xunta de Galicia, 2009.

———. "Waltercio Caldas." In *Waltercio Caldas: Máis Lugares*, 121–132. Santiago de Compostela: Centro Galego de Arte Contemporánea, Xunta de Galicia, 2008. Exhibition catalogue.

Osório, Luiz Camillo. "Outros relógios." Belo Horizonte: Celma Albuquerque Galeria de Arte, March–April 2000. In the exhibition catalogue for *Esculturas*.

———. "A Severidade do Vazio: Waltercio Caldas expõe a Série Veneza e honra a herança do experimenalismo sem abdicar da pureza aristocrática." *Bravo* 6 (March 1998): 61.

———. "Waltercio Caldas: Line, Space, and *Ginga*." In *Waltercio Caldas: Máis Lugares*, 133–143. Santiago de Compostela: Centro Galego de Arte Contemporánea, Xunta de Galicia, 2008. Exhibition catalogue.

Pérez-Oramas, Luis. "Waltercio Caldas' *Mirror of Light* and Cildo Meireles' *Thread*." In *Latin American and Caribbean Art: MoMA at El Museo*. New York: El Museo del Barrio and the Museum of Modern Art, 2004.

Ramírez, Mari Carmen. "Waltercio Caldas." In *Re-aligning Vision: Alternative Currents in South American Drawing*. Austin: Archer M. Huntington Art Gallery, Univ. of Texas at Austin, 1977.

Ribeiro, Marília Andrés. "Entrevista." In *Waltercio Caldas: O Atelier Transparente*, edited by Fernando Pedro da Silva and Marília Andrés Ribeiro. Belo Horizonte: Editora C/Arte, 2006.

Roels, Reynaldo. "Waltercio Caldas: A arte se apropria do intangível." *Jornal do Brasil*, April 15, 1986.

Salzstein, Sônia. "Above and Below the Horizon." In *Salas e Abismos*, 224–227. São Paulo: Cosac Naify, 2009. Catalogue of an exhibition at the Museu Vale.

———. "Calor branco." In *10 Esculturas: Amílcar de Castro, Carlos Fajardo, Franz Weissmann, Iole de Freitas, José Resende, Sérgio Camargo, Sérvulo Esmeraldo, Tunga,*

Waltércio Caldas, Willys de Castro. São Paulo: Gabinete de Arte Raquel Arnaud, 1989. Exhibition catalogue.

———. "Livros, superfícies rolantes." In *Livros*. Rio de Janeiro: Museu de Arte Moderna, 1999. Exhibition catalogue.

———. *Olhar o mar*. Rio de Janeiro: Galeria Sergio Milliet / Funarte, 1988. Exhibition catalogue for *Ciclo de Esculturas*.

———. "Scales." In *As esculturas ao aire libre de Waltercio Caldas*, 109–117. Santiago de Compostela: Xunta de Galicia, 2009.

———. *"Um véu."* *XLVII Bienal de Veneza: Representaçao Brasiliera*. São Paulo: Fundação Bienal de São Paulo, 1997. Catalogue of Brazil's representation in the Venice Biennial.

Salzstein-Goldberg, Sônia, and Ivo Mesquita. "Imaginários singulares." In *19a Bienal Internacional de São Paulo*. Curated by Sheila Leirner. São Paulo: Fundação Bienal de São Paulo, 1987. Exhibition catalogue.

Sebastião, Walter. "Waltercio Caldas, uma visão do contemporâneo; A precisão como arma de combate." *Estado de Minas*, January 5, 1993.

Stringer, John. "Waltercio Caldas." In *Abstract Attitudes*. New York: Center for Inter-American Relations, 1984. Exhibition catalogue.

Tassinari, Alberto. "Caldas, aparências que não enganam." *Folha de S. Paulo*, December 1987.

———. "Discutindo os limites da arte." *Folhetin, Folha de S. Paulo*, May 30, 1982.

Tavares, Zulmira Ribeiro. "Ironia e sentido." *Módulo* 61 (November 1980).

Valle, Nina. "O crisântemo está no apogeu de sua floração." In *Arte e Palavra*. Rio de Janeiro: Universidade Federal do Rio de Janeiro, 1987. Exhibition catalogue.

Varvier, Carole. "Waltercio Caldas sculpte l'air au Centre d'Art Contemporain." *Tribune des Arts, Magazine de la Tribune de Génève* 167 (October 1995).

Vicentini, Daniela. "Waltercio Caldas: O jogo da obra." Master's thesis, Pontifícia Universidade Católica do Rio de Janeiro, 2000.

"Waltercio Caldas: Galería Javier Lopez." *Lápiz* (Spain) 16, no. 138 (1998).